IMAGES
of America

SOUTH BRUNSWICK
ISLANDS
HOLDEN BEACH, OCEAN ISLE
BEACH, AND SUNSET BEACH

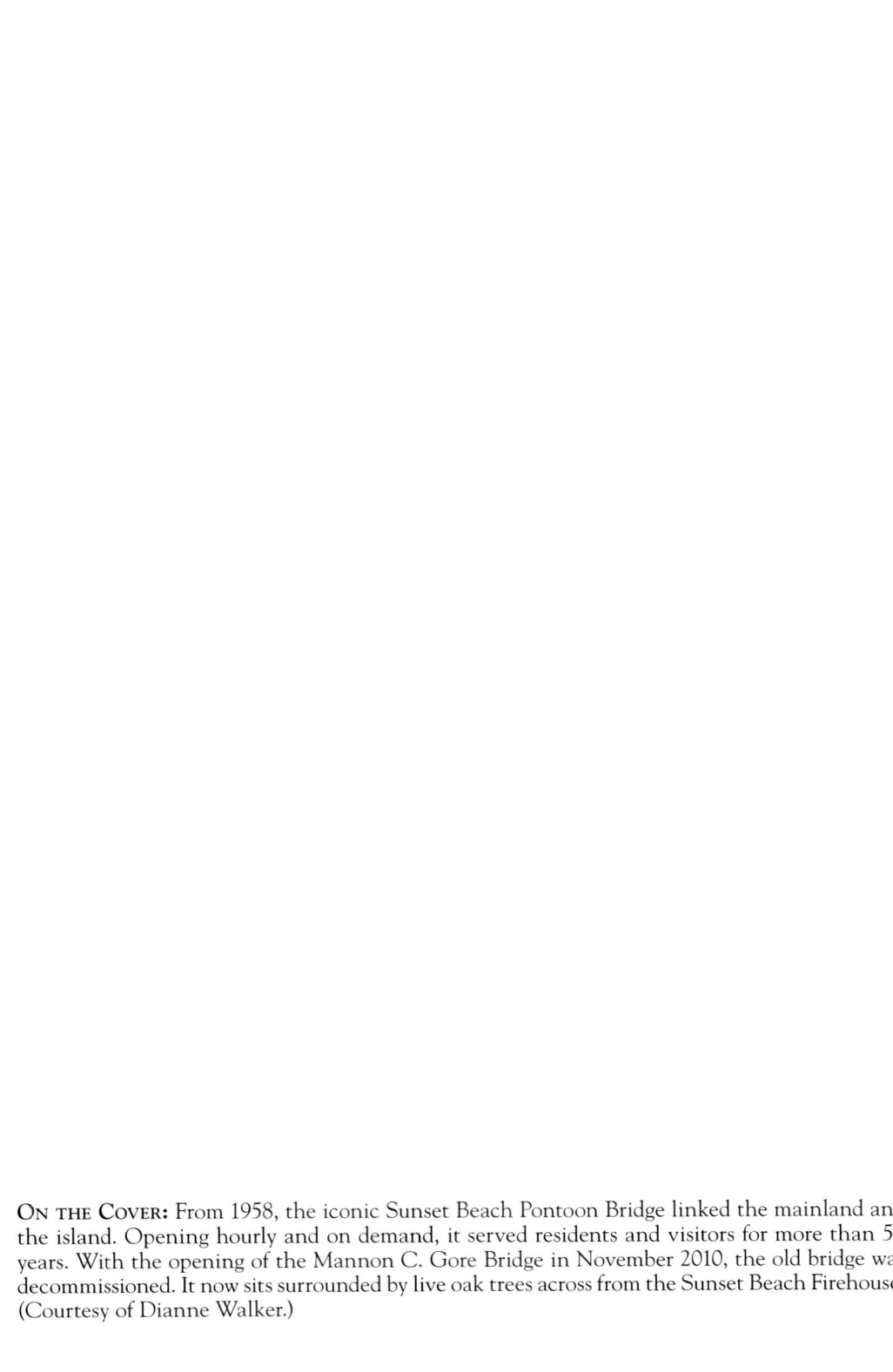

IMAGES
of America

SOUTH BRUNSWICK
ISLANDS
HOLDEN BEACH, OCEAN ISLE
BEACH, AND SUNSET BEACH

Pamela M. Koontz

ARCADIA
PUBLISHING

Published by Arcadia Publishing
Charleston, South Carolina

Printed in the United States of America

Library of Congress Control Number: 2013952329

For all general information, please contact Arcadia Publishing:
Telephone 843-853-2070
Fax 843-853-0044
E-mail sales@arcadiapublishing.com
For customer service and orders:
Toll-Free 1-888-313-2665

Visit us on the Internet at www.arcadiapublishing.com

To my parents, Jerry and Martha Koontz
and
In memory of Edward M. Gore Sr. (1932–2014)

CONTENTS

ACKNOWLEDGMENTS

First and foremost, I would like to thank God for His guidance throughout this journey. I am most grateful to everyone who generously provided photographs and helped with identifications. Special thanks are owed to Jay Holden, John Quinton Holden, Pat Sandifer, Jim Griffin, Karen Joseph, Ed Gore, Leigh Ingram, Gil Bass, Shannon Bass, Ronnie Holden, Dr. Norman Duncan, Rae Sloane Cox, Virginia Williamson, Betty Woodard, and Tripp Sloane. They were instrumental in providing photographs and most importantly their memories.

I would also like to thank Stuart Matthews, Gary Pope, Scott Duncan, Myrt Klein, Richard Lautensleger and the staff at the Carolinas Aviation Museum, Sunset Beach Town Hall, Ocean Isle Beach Town Hall, and Holden Beach Town Hall.

I am grateful to my family and friends who provided support as I battled deadlines. I would like to thank my acquisitions editor at Arcadia Publishing, Katie McAlpin, for her support during this project.

INTRODUCTION

Chartered in 1746, Brunswick County is one of the oldest counties in North Carolina. The South Brunswick Islands—Holden Beach, Ocean Isle Beach, and Sunset Beach—are man-made barrier islands formed when the North Carolina section of the Intracoastal Waterway was constructed between 1930 and 1940. Each of the pristine islands is eco-friendly and strives to maintain peaceful and natural areas for endangered wildlife. Each island has an organized Turtle Watch Program with volunteers who monitor turtle nesting and help hatchlings reach the ocean safely. Goat Island is a spoil island, which a herd of feral goats calls home, located on the seaward side of the waterway near the western side of Ocean Isle Beach and Sunset Beach. The marshland and waterways are perfect for kayaking, fishing, and viewing wildlife.

The islands are unique in that they all face east to west and at certain times of the year; you have the advantage of watching both sunrise and sunset over the Atlantic each day.

With over eight miles of oceanfront, Holden Beach is largest of the three South Brunswick Islands. It is a quiet, family-oriented destination with very little commercial development. The island has a 35-foot height limit for buildings, and almost all of the commercial property is on the mainland side of the waterway. Holden Beach also has the longest family history, starting with Benjamin Holden's acquisition of land in 1756 from King George II. Ten years after his death in 1785, Holden's estate was divided among his three sons—Amos, Joshua, and Jobe. Eventually, Jobe, who bequeathed the estate to his son William Holden, owned the entire property. In turn, that son passed the property to John Holden Sr. who later bequeathed the property to his son John Holden Jr. In developing the property, Holden Jr. eventually divided the estate among his six surviving children—Luther, Grover, J. Herbert, Rothschild, S. Edgar, and Rhoda—who have all played important roles in developing Holden Beach. Luther's son John F. Holden was also very involved in the expansion of the island. His son John "Alan" Holden was the first baby born to a Holden Beach resident, and his son Lyn is involved in many business ventures, including the Beach Mart located on the mainland.

In the 1960s, Drufus Griffin became general manager of the newly formed Holden Beach Realty and worked closely with Dr. R.H. Holden, Rhoda Holden McMillian, and S. Edgar Holden with development of their Holden Beach property. The group also purchased property on Robinson Beach and also Colonial Beach (the last 1.5 miles, which is now Holden Beach West). John Herbert Holden Jr. and Sue Marion Holden's sons Jay and David were instilled with a deep appreciation of the natural beauty of the land they inherited. As young men, they were always fascinated with the towering peaks, steep slopes, and hidden valleys of the dunes. So when it came time to develop their land, they wanted to do it the way their parents would have done it—with preservation of the dunes in mind. Dunescape is a landscape that is very different from anything else on the island.

Together with other developers and landowners, including the Holdens, Griffins, and Henifords, Holden Beach continues to focus on and maintain a quiet, family beach. The unofficial motto then that remains today is to "grow without change."

Odell Williamson started purchasing parts of land in the late 1940s that would later become Ocean Isle Beach. In partnership with Mannon C. Gore, Williamson started selling lots in the early 1950s, and a few homes were built. However, Hurricane Hazel in October 1954 set back the initial work when the few island homes were destroyed as the storm moved through the area. Nine of eleven people who were on the island, including Odell Williamson's sister, lost their lives. One month later, Mannon and Odell agreed to dissolve their partnership. This seven-mile long island was incorporated as the Town of Ocean Isle Beach in 1959. Willa Rae Sloane and George A. Sloane, along with their children, Tripp and Debbie, were the only permanent residents on the island from 1955 to 1963. The Sloane family opened an oceanfront hotel where they lived and operated a real estate office, and they were instrumental in the development of the island. They operated several businesses including the ABC Store, Breakers, and the Ocean Isle Motel. Today, the Ocean Isle Inn stands where the original motel was located. Odell Williamson became the mayor of Ocean Isle Beach and built the Ocean Isle Municipal Airport and a chapel in honor of his wife, Virginia. Virginia Williamson served as mayor and managed many of the businesses the family built, including the Ocean Isle Pier, real estate office, and miniature golf course.

The Museum of Coastal Carolina opened on May 25, 1991, in Ocean Isle Beach. It is the only museum located on a North Carolina barrier island. Stuart and Louise Ingram were instrumental in the development of both the museum and Ingram Planetarium.

Sunset started out as a quiet residential community planned that way by Mannon C. Gore when he put a 35-foot height limit on island buildings. Sunset Beach is unique because the town encompasses both mainland area and an island. Gore purchased Bald Beach from the Brooks family in 1955 with money from the sale of his farms. He was so impressed by the beautiful sunsets that he watched from his home on Ocean Isle that he renamed the island Sunset Beach.

Gore purchased 500 acres of mainland property along the Intracoastal Waterway from International Paper Company and began developing the Sunset Beach community. Sunset Beach is the smallest of the South Brunswick Islands, but boasts three miles of a remarkably wide beach and marsh areas with a rich ecosystem. Sunset Beach also offers a special delight—a walk to Bird Island at the southern end of Sunset Beach where you will find the "Kindred Spirit" mailbox located among the dunes. In 1958, there was no island access except by boat, so Gore designed and installed a pontoon swing bridge that led traffic to a causeway. The old pontoon swing bridge that opened on the hour every hour from 1958 was decommissioned in November 2010, but it continues to be a symbol of Sunset Beach. The old 110-foot span and the tender house were moved by tugboat and crane to the mainland, where the Old Bridge Preservation Society is turning the house into a museum.

Gore also built the original Vesta Pier and named it after the Civil War blockade-runner buried in the sand beside the present Sunset Beach Pier. To aid Mannon Gore, his son Edward M. Gore Sr. joined the business in the late 1950s after returning home from service. Together, they successfully developed and shaped the island into what it is today. Sunset Beach was incorporated in 1963 with Mannon C. Gore serving as the first mayor.

All three islands have remained true to the vision of the developers—quiet, pristine beaches with a long-standing focus on families.

Along with historic landmarks, this book includes a collection of photographs of the individuals and families who collectively helped to develop the South Brunswick Islands. If anyone or anything was left out of this pictorial history, it was not intentional. It is up to us to preserve memories and pass them forward. These photographs are simply threads that weave a tapestry of history.

One

HOLDEN BEACH

Holden Beach was originally named Holden's Beach, and some locals still use this earlier name. Looking to decorate his new apartment in Rehoboth a few years ago, artist Aurelio "Rail" Grisanty went searching for unique images of the coastal town. Specifically, he envisioned vintage travel posters with beach scenes evoking whimsical nostalgia. He could not find anything like these images, so he decided to create them himself. (Courtesy of Aurelio Grisanty/Beach Town Posters.)

John Holden Jr. (1858–1932) was a fourth-generation owner of the island. He started a commercial fishery on the island and surveyed a section in 1924, which he called Holden's Beach Resort; the plat represented the first subdivision of beach property in Brunswick County. (Courtesy of John Quinton Holden.)

Cornelia Jane Kirby Holden (1859–1939) was the wife of John Holder Jr. and mother to Rothschild H., Luther S., Grover T., John H., Rebecca J., Samuel E., and Rhoda Holden. The children were reared at the Old Holden Home approximately two miles from the ocean. (Courtesy of John Quinton Holden.)

Dr. R.H. Holden is seen here in his dental office in 1960. After practicing dentistry for 23 years in Durham, Dr. Holden moved back to Brunswick County in 1947 and opened a new practice in Shallotte. In his early development endeavors in 1947, he built a large two-story, eight-room, oceanfront hotel and several cottages. (Courtesy of John Quinton Holden.)

This is a rare 1900s photograph of the John Holden Jr. family. His children went on to pursue his original plans to create a family resort. Pictured are, from left to right, (first row) Janie and Edgar; (second row) John Holden Jr.'s mother, Charlotte, John Holden Jr., his wife, Cornelia, Luther, and Grover; (third row) Rhoda, John Herbert, and Rothschild. Janie died in 1918 during the flu epidemic. (Courtesy of John Quinton Holden.)

Dr. R.H. Holden contracted with R.E. Bellamy and Sons to construct the Ocean View Tavern in 1947. It had eight rooms upstairs and a café downstairs along with a private party room and great room. Dr. Holden employed a cook from Greece who prepared excellent food. No alcohol was served, but patrons could bring their own alcoholic beverages. After Hurricane Hazel, the tavern was converted into a large home, and the name was changed to Sandalwood. (Courtesy of John Quinton Holden.)

In 1947, Dr. R.H. Holden moved back to Brunswick County and made plans to start development on Holden Beach. One of his first projects was the Ocean View Tavern. Shovel in hand and with his son John, he prepares for the ground-breaking ceremony for the tavern. (Courtesy of John Quinton Holden.)

Three Civil War blockade-runners sank off the coast in Lockwoods Folly Inlet. The blockade-runner *Elizabeth*, the blockade-runner *Bendigo*, and the blockade-runner *Ranger* are all owned by the State of North Carolina and listed in the National Register as part of an archeological district. The *Elizabeth* was lost in 1863. Only a few months after the loss of the *Elizabeth*, the *Bendigo*, while running close to shore, mistook the wreck for a Union blockader and attempted to pass inshore. The *Ranger* was beached one mile west of Lockwoods Folly Inlet and destroyed by fire in 1864. The USS *Iron Age* also met its fate at Lockwoods Folly Inlet and was grounded on January 10, 1864. (Courtesy of Pat Sandifer.)

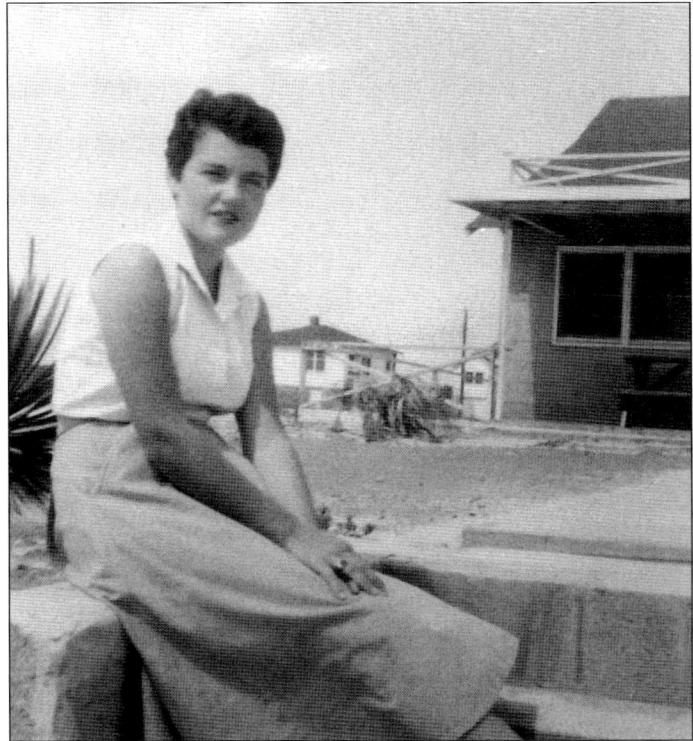

In the summer of 1953, Rose Holden married Leo Cole. The cottage in the background, named the Key Shell, was completely remodeled for the wedding reception. In October 1954, Hurricane Hazel totally destroyed the cottage. Rose's wedding dress that had been stored in a closet in the Key Shell was found hanging from a tree more than a quarter of a mile across the waterway. (Courtesy of John Quinton Holden.)

Although the Holden property was a successful commercial fishing center, John Holden Jr. envisioned beachfront property in 1924 when he presented the first subdivision in Brunswick County, Holden's Beach. From 1925 to 1926, he built a 1.5-mile road from the home place to the coast that included a bridge and a causeway. He then built a 10-bedroom hotel with a kitchen and dining room where his wife prepared and served meals to the visitors. (Courtesy of Mark Houde.)

Here is Holden Seafood's trawler *Pat* in 1966. The trawler towed barges filled with hundreds of bushels of oysters and clams through the Long Beach swing bridge. The oysters were harvested from Buzzard Bay behind Bald Head Island. The North Carolina Division of Marine Fisheries hired a local fisherman once a year to move the oysters from polluted waters to clean waters. These oysters were planted in the Shallotte River to be harvested the next season. Holden's had the only river lease and was allowed to move clams to the six-mile lease where they were raked up and sold to fish markets the next season. In the background, one can see pogie boats at the old Southport Pogie Plant. (Courtesy of Ronnie Holden.)

14

In 1954, Holden Beach had approximately 300 homes, and when Hurricane Hazel struck North Carolina on October 15, 1954, more than 90 percent of the houses were destroyed. Hazel hit the southern coast of North Carolina at the worst time: the year's highest lunar tide, called the "marsh hen tide" by local hunters. Marsh hens are medium-sized waterbirds. Winds were clocked at 150 miles per hour on Holden Beach. Total North Carolina damages exceeded $1 billion. (Courtesy of Gil Bass.)

Luther S. Holden, a permanent resident since 1946, was one of three men on the island when Hurricane Hazel hit. Holden managed to be the only survivor by moving from cottage to cottage as he dodged debris along the way. He eventually found refuge in one of the few cottages that withstood the storm. (Courtesy of John Q. Holden.)

This c. 1940 view of the Holden Beach ferry is looking toward the mainland, with John Herbert Holden's store in the background. From the time the ferry began operation in 1934 until the early 1940s, it was pulled across the waterway by hand. Brothers Harvey W. Kirby and Jesse W. Kirby were two of the original ferry operators. The men used a notched hickory jack stick to catch hold of the cable and pull the ferry across. John Herbert Holden Jr. is on the left posing as a ferryman. (Courtesy of Jay Holden.)

The Holden Beach Ferry is pictured in the 1950s. In the early 1950s, the ferry operated 24 hours a day when possible, depending upon the tide and wind. Albert Clemmons, the operator, was on duty February 20, 1954, when the ferry ceased operation. It was replaced with a turn bridge. (Courtesy of Jay Holden.)

Before the Holden Beach Pier was constructed, Mary's Inlet was where many of the commercial fishermen fished. The inlet was filled in when the Intracoastal Waterway was dredged, but Hurricane Hazel opened another inlet in almost the same spot. A few years later, it was filled in again, and the pier was built. Here, three proud fishermen, including pier owner Lonnie Small (center), show off their catch of the day at the Holden Beach Pier. (Courtesy of Gil Bass.)

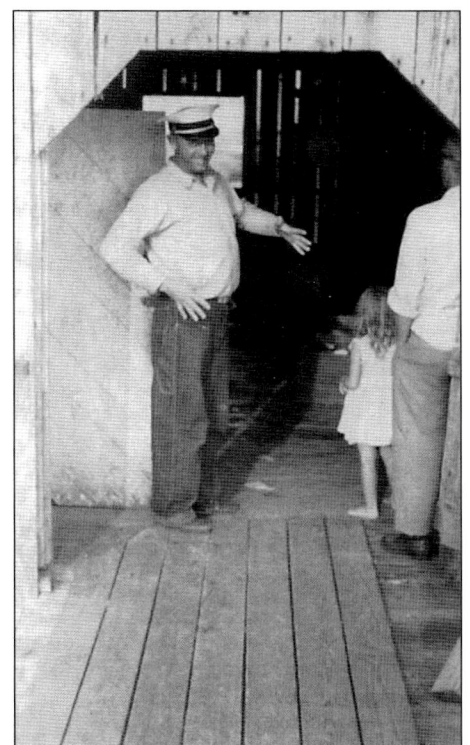

Goodman Fulford owned Fulford's Fish House in 1950 and is seen here showing visitors the fresh fish and shrimp catch of the day. Although the main work at the fish house was taking in and preparing seafood to sell, it was a social and community gathering site as well. The fisherman would tell captivating stories and just for measure throw in a few tall tales. There was never a shortage of entertainment at the establishment. (Courtesy of John Allen.)

Pictured is the ferry landing on the mainland side in the late 1930s to early 1940s. In the foreground are the fenders that helped guide the ferry into the ramp and helped protect the ferry from strong running tides and boat wakes. In the background on the right is Herbert Holden's store, and in the middle and left are his rental cabins. People who came to fish in the Intracoastal Waterway primarily rented these. (Courtesy of Jay Holden.)

These shrimp boats are pictured at the old Holden Beach Coast Guard dock. The government ordered a general blackout in August 1942. At that time, the US Coast Guard stationed horse patrols along Holden Beach in order to enforce the blackout code. House lights were turned off at night so that lights onshore would not help German U-boats find their way in the darkness. The U-boats were torpedoing ships when they were silhouetted against the lit-up coastline. More than 90 percent of ship sinkings off the coast during the four years of submarine attacks during World War II occurred during the first six months of 1942. (Courtesy of John Quinton Holden.)

The first worship service in Holden Beach Chapel was held on June 11, 1961. Prior to the chapel's construction, worship services were held at the old pavilion, which was destroyed by Hurricane Hazel in 1954. After Hazel, property owners Lonnie and Elgie Small, Dr. R.H. and Emma Holden, Rhoda Holden McMillian, Edgar Holden, Evelyn Thompson, and Mr. and Mrs. James S. Pete Moffitt and other guests met in their homes for Bible study. They saw the need for the construction of a chapel. Lonnie Small, who always attributed his success to God, spearheaded the fundraising. The first service was held in the chapel in 1961. (Courtesy of Jay Holden.)

The early-1980s ground-breaking ceremony for the Holden Beach Chapel expansion is seen here. In August 1997, the board of trustees voted to purchase the home adjoining the west end of the parking lot to be used as a parsonage. The current sanctuary was dedicated in November 2003. (Courtesy of Holden Beach Chapel.)

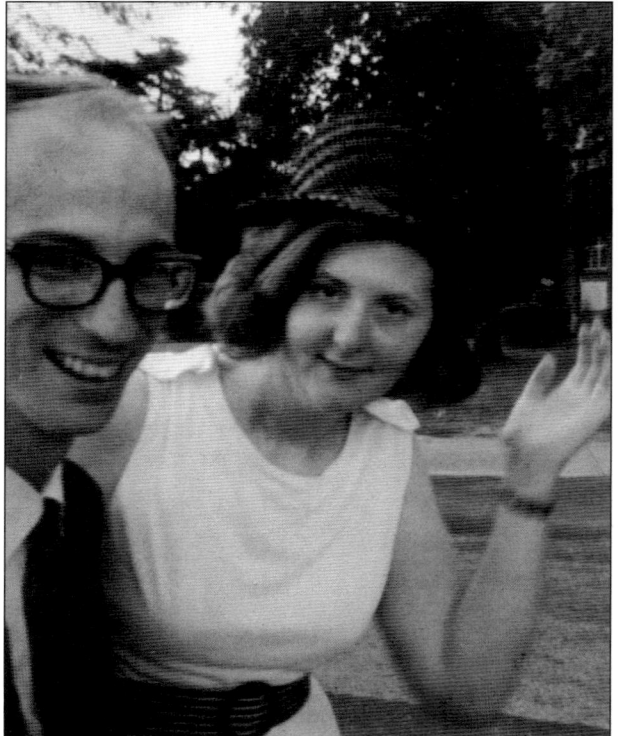

Lonnie Small and his wife, Elgie, are seen in 1963. Elgie always greeted customers with a smile and was known for her friendly service. She and Lonnie would listen to fish stories as they waited on customers. Being a popular spot, the pier served as the first polling spot for the town's first mayoral election. John F. Holden was elected mayor, and J.D. Griffin Sr. served as mayor pro tem. (Courtesy of Gil Bass.)

Gil Bass and Janet Small met while attending Campbell College and were married on June 28, 1968. They took over operations of the pier in 1982. Gil currently operates the pier with the help of his daughter Shannon. It features a restaurant, gift shop, and campground. The Holden Beach Pier is still known for friendly service, and the locals have no shortage of fish stories. (Courtesy of Shannon Bass Bradshaw.)

Lonnie Small (left) meets with Dr. R.H. Holden as they discuss pier operations. Small's dream was to build and operate a fishing pier. In 1960, with the help of a group of investors, his dream came true with the completion of the 1,142-foot-long pier built by Odell Williamson of Ocean Isle Beach. (Courtesy of Gil Bass.)

Dr. R.H. Holden married Emma Davis of Durham in 1924. After returning to Holden Beach, they were very active in the community and the development of the island and instrumental in the building of the chapel. (Courtesy of John Quinton Holden.)

HOLDEN BEACH FISHING PIER AND CAMPGROUND Photo by Jak Smyr

Lonnie Dalton Small grew up in the small town of Fair Bluff, North Carolina, and was the son of a tenant farmer. Lonnie had dreams and visions for Holden Beach. He wanted a great place for fishermen to come to, so he developed the Holden Beach Pier and Campground. The largest fish caught from the pier was a tarpon weighing 110 pounds, in 1982. (Courtesy of Gil Bass.)

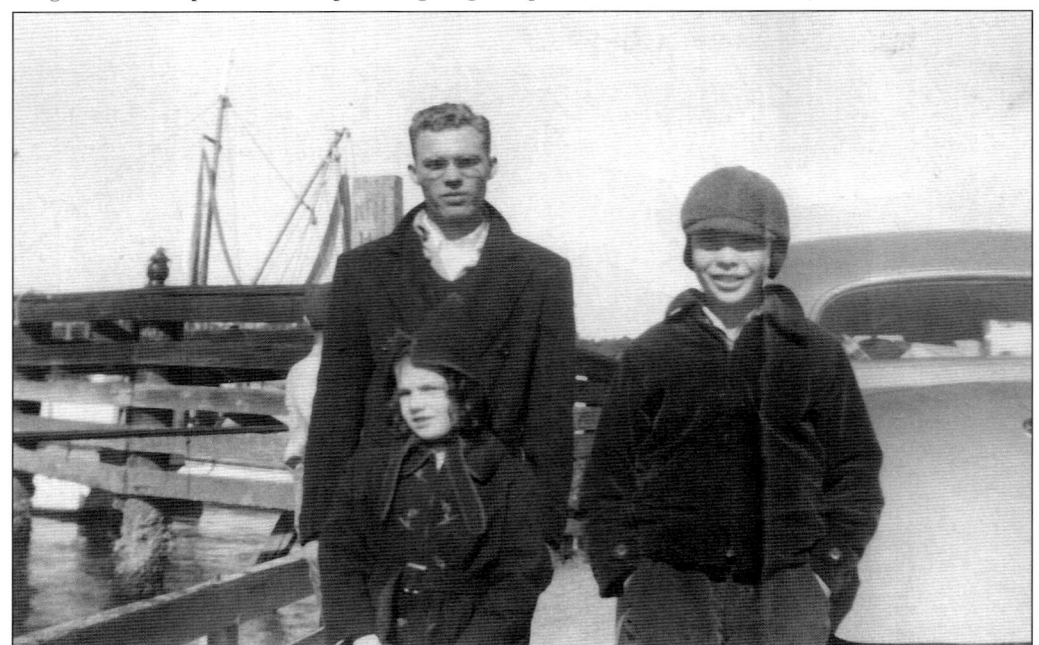

John Herbert Holden Jr. is seen standing with his niece Rose Marie and nephew Hal Holden aboard the ferry. From the time the ferry began operation in 1934 until the early 1940s, it was pulled across the waterway by hand. (Courtesy of John Quinton Holden.)

A young woman casts her line at the newly built pier. The pier was damaged by Hurricane Hugo in 1989 and then rebuilt. When Hurricane Floyd made landfall on September 16, 1999, it was a Category 2 hurricane with winds of 104 miles per hour. At its peak, Floyd had maximum sustained winds of 156 miles per hour. The Holden Beach Pier was damaged, and it was rebuilt to its current length of 750 feet. (Courtesy of Gil Bass.)

In 1962, the Oceanside Apartments rented for $14 per night, and in 2014, they rented for $90 per night. (Courtesy of Gil Bass.)

Hurricane Hugo hit Holden Beach Pier in September 1989 as a Category 4 hurricane. With maximum wind gusts of over 140 miles per hour, it had a severe impact on the beaches of Brunswick County. A Hurricane Hunter aircraft measured a wind speed of 160 miles per hour at 12,000 feet just before landfall. Only two Category 4 storms have ever hit the North Carolina coast—Hugo and Hazel. (Courtesy of Gil Bass.)

As the path of Hurricane Hugo moved across Holden Beach, the storm totally destroyed a section of the pier. In North Carolina alone, damages exceeded $1 billion, with a large portion occurring in the lumber industry. About 68,000 acres of North Carolina's forests were destroyed, and another 2.7 million acres were damaged. In total, the state lost $435 million worth of lumber. Brunswick County had $31 million in damages. Over 120 homes were destroyed along the coast by Hugo's winds and 8-to-10-foot storm surge. (Courtesy of Gil Bass.)

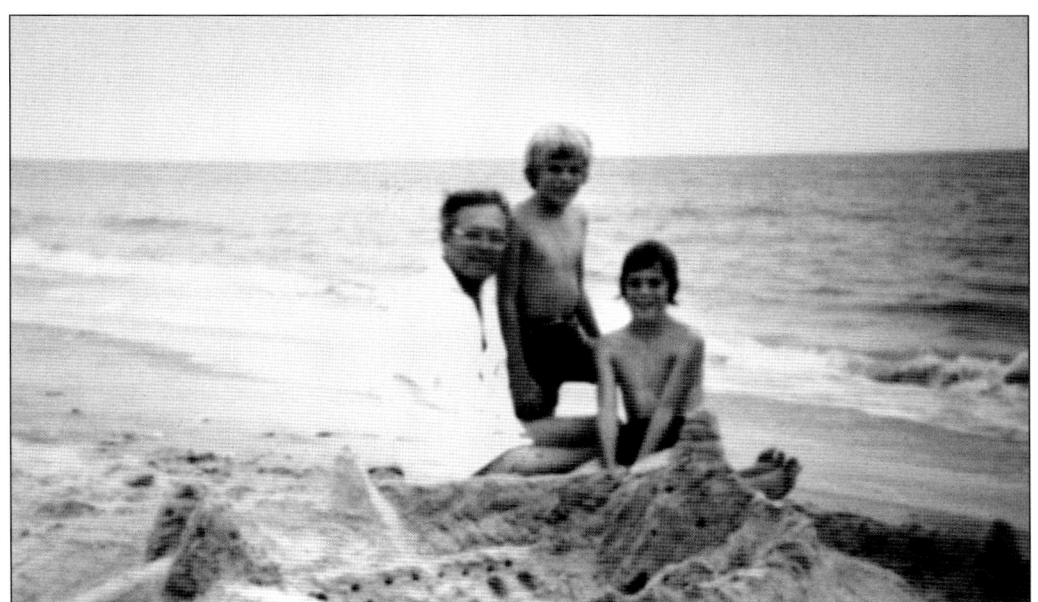

John Herbert Holden Jr. is building sand castles with his sons David (left) and Jay on Holden Beach in the summer of 1972. John Herbert Holden Jr. appreciated the beauty of the island and instilled a sense of preservation upon his sons. In developing Dunescape, they included protective covenants so that a portion of each lot would remain in its natural state, balancing development with preservation. (Courtesy of Jay Holden.)

This photograph of John Herbert Holden Sr. (1888–1946) and Eva June Dobson Holden (1895–1954) was taken in 1919. Standing to the left is Herbert's brother S. Edgar Holden (1897–1977). They are outside the old home place of John and Cornelia Jane Kirby Holden. (Courtesy of Jay Holden.)

Four generations are represented by Julia May Dougherty, Lois Dougherty Griffin, and Pat Sandifer Griffin with daughter Victoria. Pat and Victoria are currently active in day-to-day operations of Holden Beach Properties. (Courtesy of Pat Sandifer.)

May Lois Dougherty Griffin was the first Miss Charleston, South Carolina. She married James Drufus Griffin in 1936, and in 1961, the Griffins moved the family to Holden Beach and started the family business. Along with the coveted title of Miss Charleston, Lois also had a lifetime association with the Daughters of the American Revolution. (Courtesy of Pat Sandifer.)

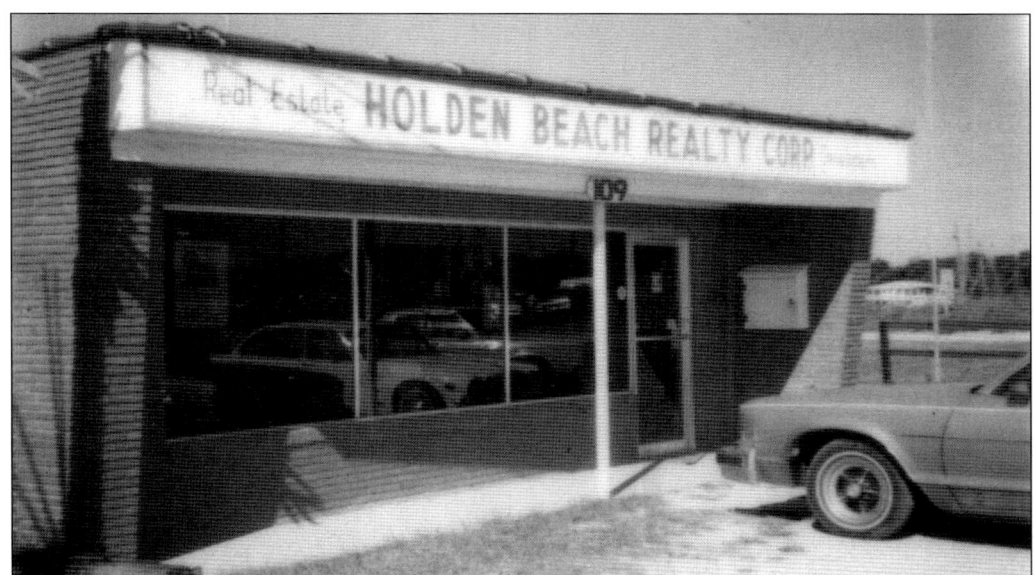

Lois and James D. Griffin Sr. and children Pat and Jim moved to Holden Beach in 1961. They built and began Holden Beach Realty Corp. In 1965, they received the contract for the first and only post office on the island. Jim Griffin was the first postmaster and holds that position today. The post office started in the building located at 109 Jordan Boulevard and was later moved to the old hotel building, which was purchased from Dr. R.H. Holden. Pat Griffin Sandifer and her husband, David, bought the rental part of the company from her parents and later renamed it Holden Beach Properties. They moved it and the post office to 108 Jordan Boulevard, which is across from the original post office. Bonnie Cox, with her son Steven, currently operates Sandman's Candyland in the historic post office. (Courtesy of Pat Sandifer.)

After moving to Holden Beach in 1961, Drufus Griffin was instrumental in the early development of the island, working directly with the members of the Holden heirs. Always active in politics, Griffin founded a Young Democrats Club during the presidency of Franklin D. Roosevelt. (Courtesy of Pat Sandifer.)

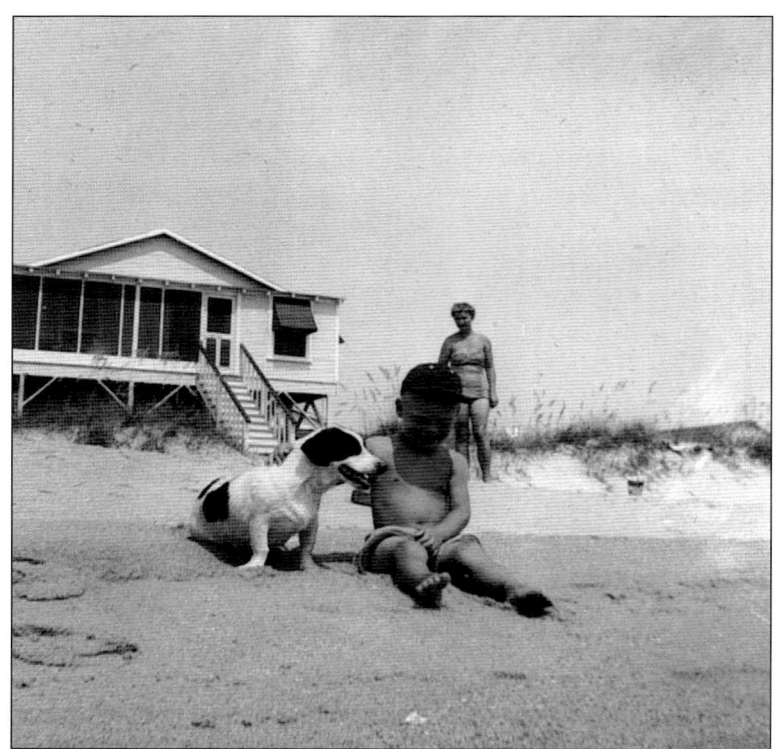

On the beach in 1957, Randy Duncan enjoys a day with his dog Measles while his mother Hazel watches in the background. In the early years of development, there were no restrictions regarding dogs on the beach. As of this writing, Holden Beach does not allow dogs on the beach from May 20 to September 10, except between 5:00 p.m. and 9:00 a.m. daily. A dog must be on a leash at all times on the island. (Courtesy of Scott Duncan.)

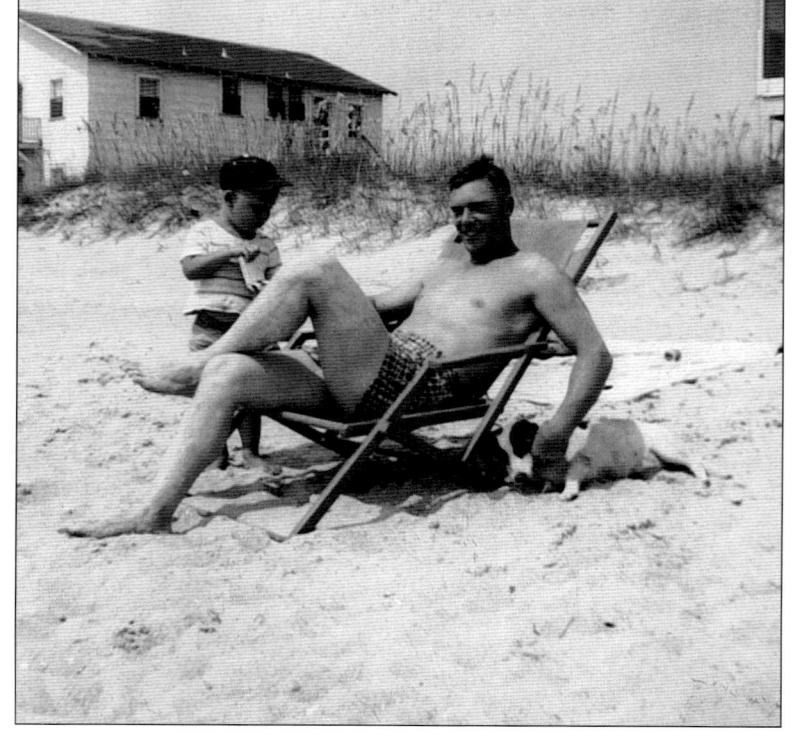

Dr. Norman Duncan enjoys a day at the beach with son Randy. The Duncan family spent more than 50 years at Holden Beach. Dr. Duncan was the unofficial directions "czar" at the beach as he traveled the backstreets on his three-wheeled bicycle. (Courtesy of Scott Duncan.)

Fish would be brought into the mullet shed for cleaning and then washed in the ocean in large baskets made with strips of white oak. Salt was used to preserve the fish, and then they were packed in barrels for shipping. (Courtesy of John Quinton Holden.)

Nancy Todd strikes a pose at Theedy's in 1962. Theedy's Place was a popular hangout during the 1960s. A person could grab a couple of snacks and a soft drink, and then put a boat in the water to go skiing or sailing. Elwood Newman, also known as Captain Newman, an islander since the 1940s, taught hundreds of kids how to water-ski. Theedy's Place was also an excellent spot for fishing. (Courtesy of Pat Sandifer.)

Theedy "Theedycloth" Faircloth leased the lot and building from Dr. R.H. Holden. It was next to a small yacht basin that Dr. Holden had dredged out in 1946–1947 and in which he installed three piers. Transit boats could tie up for a day or two at no charge. A boat ramp at Theedy's was put there by the county roads commission at Dr. Holden's request. There was no charge for boat launch and retrieval. (Courtesy of John Quinton Holden.)

Hurricane Hazel damaged Theedy's Place so badly that no repair efforts were made. There is little evidence of its existence today. It was located a block west from the present bridge at the foot of Davis Street. (Courtesy of John Quinton Holden.)

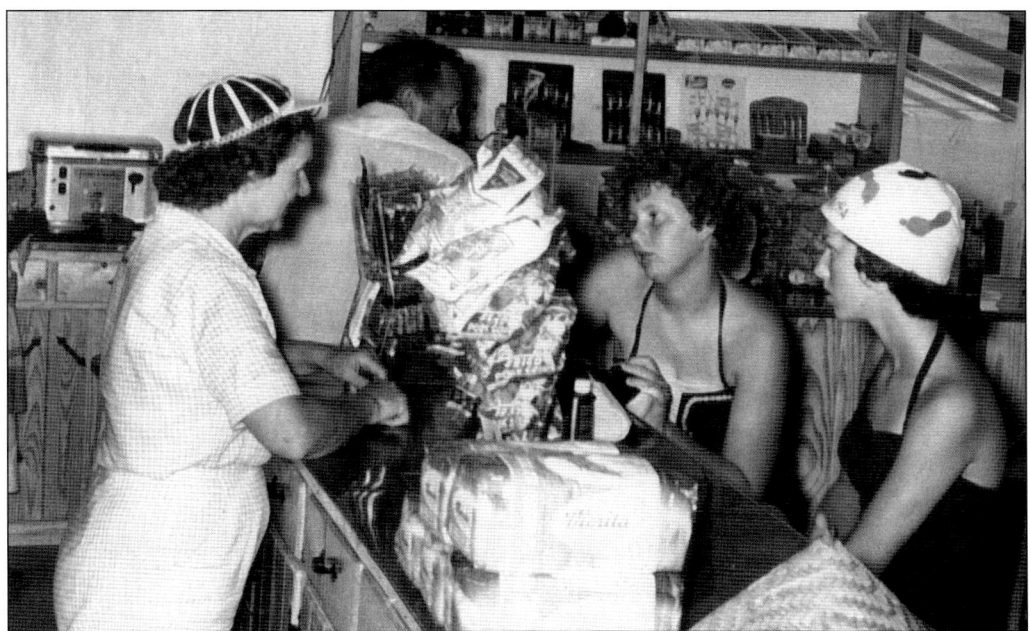

Pictured is the Pier Snack Bar. Elgie Small takes an order for her daughter Janet Small (center) and an unidentified friend. During the 1960s, the pier was a popular hangout, and teens would gather around the counter at the snack bar. While on breaks from attending Campbell College, Janet would help out around the pier. (Courtesy of Gil Bass.)

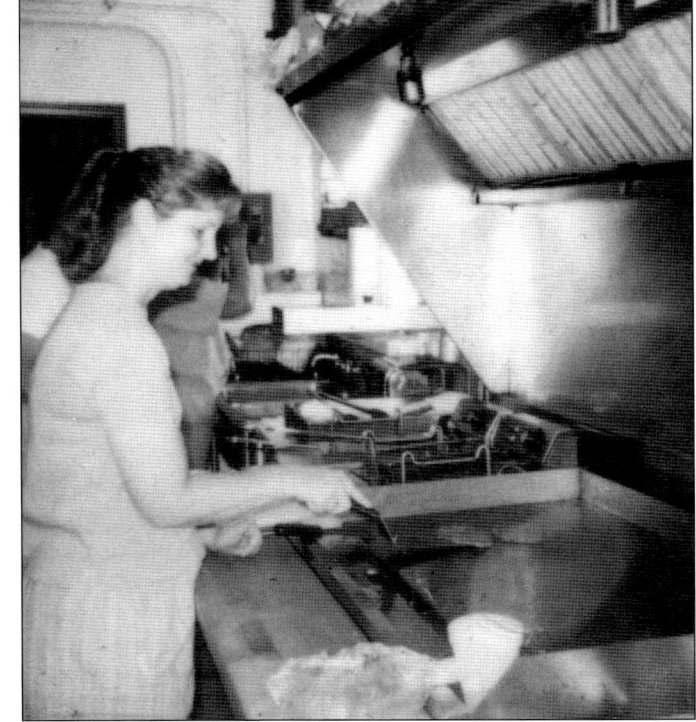

Third-generation resident and employee Shannon Bass tends the grill. Shannon, following in her mother's footsteps, worked during her college breaks at the pier. Her grandfather purchased the land for the pier in 1958 for $4,000. Construction soon followed, and the pier was opened in 1959 but not completed until 1960. (Courtesy of Shannon Bass Bradshaw.)

Pictured is Mary's Gone Wild. Artist Mary Paulsen says God spoke to her in a vision in 1998 and told her to take up a brush and paint and showed her what to do. She began creating works of art using the complicated technique of reverse painting on glass using recycled windows as her canvas. She also paints on wine glasses, plates, furniture, and most anything that can be recycled. Her magical folk art garden has small houses built of bottles, tree houses, dollhouses, and even round houses. The interest in her folk art has sparked a short documentary produced by Blaire Johnson that aired on UNC-TV and a book, *Doing the Vision: The Folk Art of Mary Paulsen*, by Gale Terry. She has also been featured in the *New York Times*, *Southern Living*, and numerous other publications. Mary's paintings hang in all 50 states and in numerous countries around the world. (Author's collection.)

John F. and Johnsie Holden (right and second from right) attend a local event. The Holdens were involved in the development of Holden Beach and active in the community. Johnsie Marie McCourry Holden was a writer, scholar, and visionary. She served as a high school principal before being recruited by the Army Signal Corps for cryptographic work in breaking the Japanese codes in World War II. She was the first postmistress of a seasonal post office at Holden Beach, and she organized and led the first Girl Scout troop in the Holden Beach area. She wrote two books: *Riverhead*, a history of the North Carolina mountains from before the Revolutionary War through the years of development, and *Heartening Heritage*, which concentrates on the history of churches in Brunswick County. (Courtesy of Pat Sandifer.)

Henrietta Allen (left) and friends, from left to right, Lola Rankin, Winnie Stewart, Etta Allen, and Alice Watkins enjoy a day at the beach. All of the women were active in the community. (Courtesy of John Allen.)

This c. 1940 picture shows a mullet fishery. John Herbert Holden Sr., located on the far right in the white hat, is seen with crew members of the fishery. A lookout was stationed on the beach east of the fishery on a stand like the ones lifeguards use today. When he spotted a school of mullet approaching, he signaled the crew at the fishery. Quickly and quietly, they pushed a double-ended boat into the water; it was pointed at the bow and stern to better handle the waves. Four men pulled at 16-foot-long oars, pushing through the surf. The captain, who, from 1920 to 1965, was T. Hendrix Phelps, put out the seine and kept the oarsmen in time. The lookout helped guide them around the mullet. Once they encircled the school, they rowed for shore. The rest of the crew then splashed into the water, lifting up the net to keep the fish from jumping over it. Sometimes, the schools were so big, it took every bit of the strength of all 12 men to pull the seine ashore. (Courtesy of Jay Holden.)

The Barna House was constructed shortly after development began on Holden Beach. It was completed between 1938 and 1939 and totally destroyed by Hurricane Hazel in 1954. (Courtesy of John Allen.)

Barna and Henrietta Allen were originally from Troy, North Carolina. Barna was by definition an entrepreneur. He started one of the first Ford dealerships, a wholesale grocery store, hardware store, and general store. He was also co-owner of a textile mill. They were the proud parents of eight successful children. (Courtesy of John Allen.)

Two

OCEAN ISLE BEACH

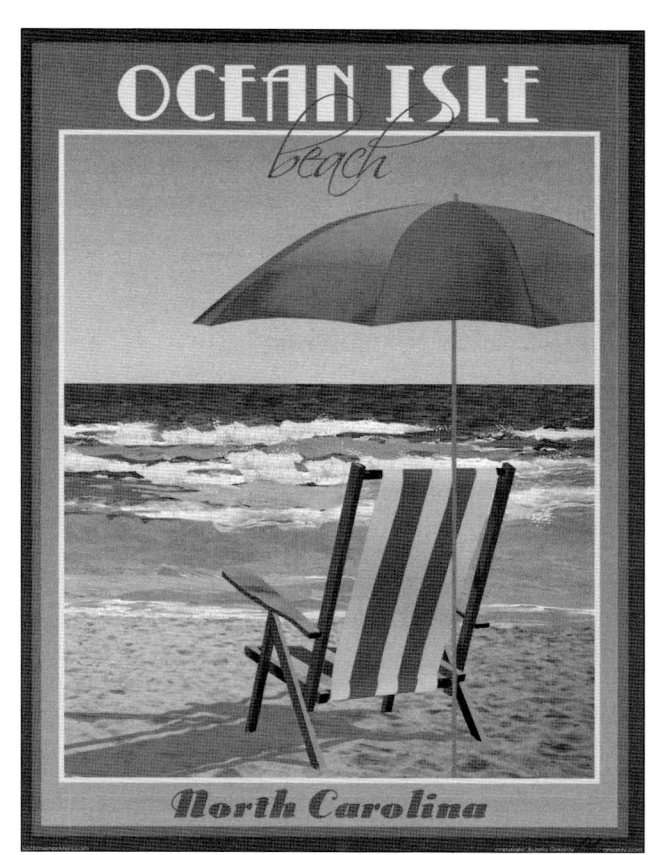

Ocean Isle was originally called Hale Beach. It was named after Hale Swamp and was divided into three sections: Brooks Beach on the west end, Little Beach on the east end, and Gause Beach in the center. (Courtesy of Aurelio Grisanty/Beach Town Posters.)

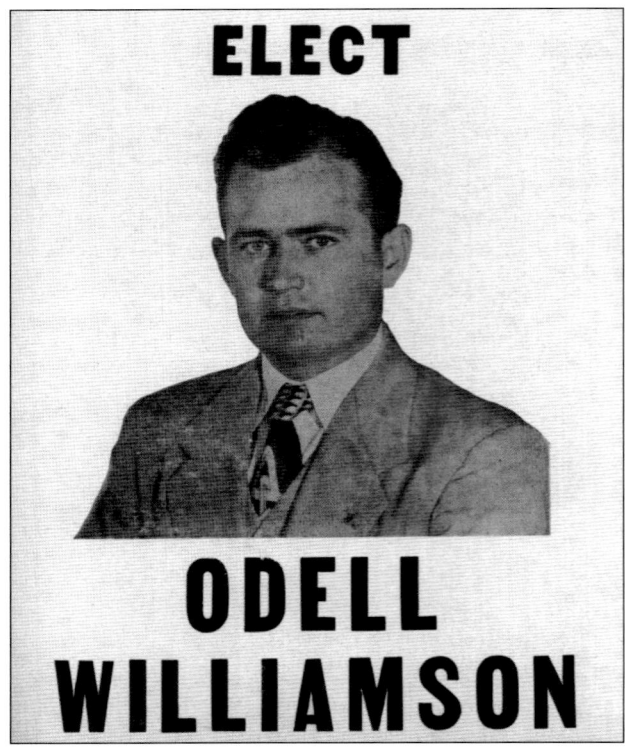

ELECT

ODELL WILLIAMSON

Odell Williamson, a consummate politician, was elected to the 1947 North Carolina house of representatives when he was 25 years old and returned to the house in 1951 and 1953. He lost his race for the 1949 state senate to S. Bunn Frink. (Courtesy of Virginia Williamson.)

Odell Williamson served as the first mayor of Ocean Isle Beach from 1959 to 1963 and later from 1974 to 1975. While serving as mayor, he was putting into place the infrastructure of Ocean Isle using his previous political experience and connections to expedite the process. (Courtesy of Town of Ocean Isle Beach.)

Homer Johnston served as mayor of Ocean Isle Beach from 1963 to 1967. Homer also owned and operated a real estate office on Ocean Isle. (Courtesy of Town of Ocean Isle Beach.)

George A. Sloane served as mayor of Ocean Isle Beach from 1967 to 1969. While in office, George used his business background to put in place policies and procedures that allowed the Town of Ocean Isle to operate more efficiently. (Courtesy of Town of Ocean Isle Beach.)

Virginia Williamson served as mayor of Ocean Isle Beach from 1969 to 1973. Taking over the helm and following in her mother's footsteps, daughter LaDane Williamson served as mayor from 1973 to 1987. (Courtesy of Town of Ocean Isle Beach.)

Odell Williamson was often called the "Father of Brunswick County." He was a graduate of Waccamaw High School, and in 1942, Williamson was called to service in the US Army and served as a reconnaissance pilot for the field artillery. He flew liaison planes in the 30th Division. (Courtesy of Virginia Williamson.)

Home from the war, Odell Williamson would fly over what is now Ocean Isle Beach and plan how he would someday develop it. Originally, the island was named Hale Beach and was later divided into three separate beaches: Brooks Beach, the west end; Little Beach, the east end; and Gause Beach, located in the center of the island. (Courtesy of Virginia Williamson.)

Odell Williamson built the first airport on the east end of the island in the 1950s, but because of the crosswinds, he had to move it to the mainland. The map for the mainland airport is dated 1972 and shows a dirt runway and one hangar, Odell's. Ocean Isle Beach Airport was completed in May 1979. In 1985, plans were made to pave the airport. The Odell Williamson Municipal Airport is publicly owned. (Courtesy of Tripp Sloane.)

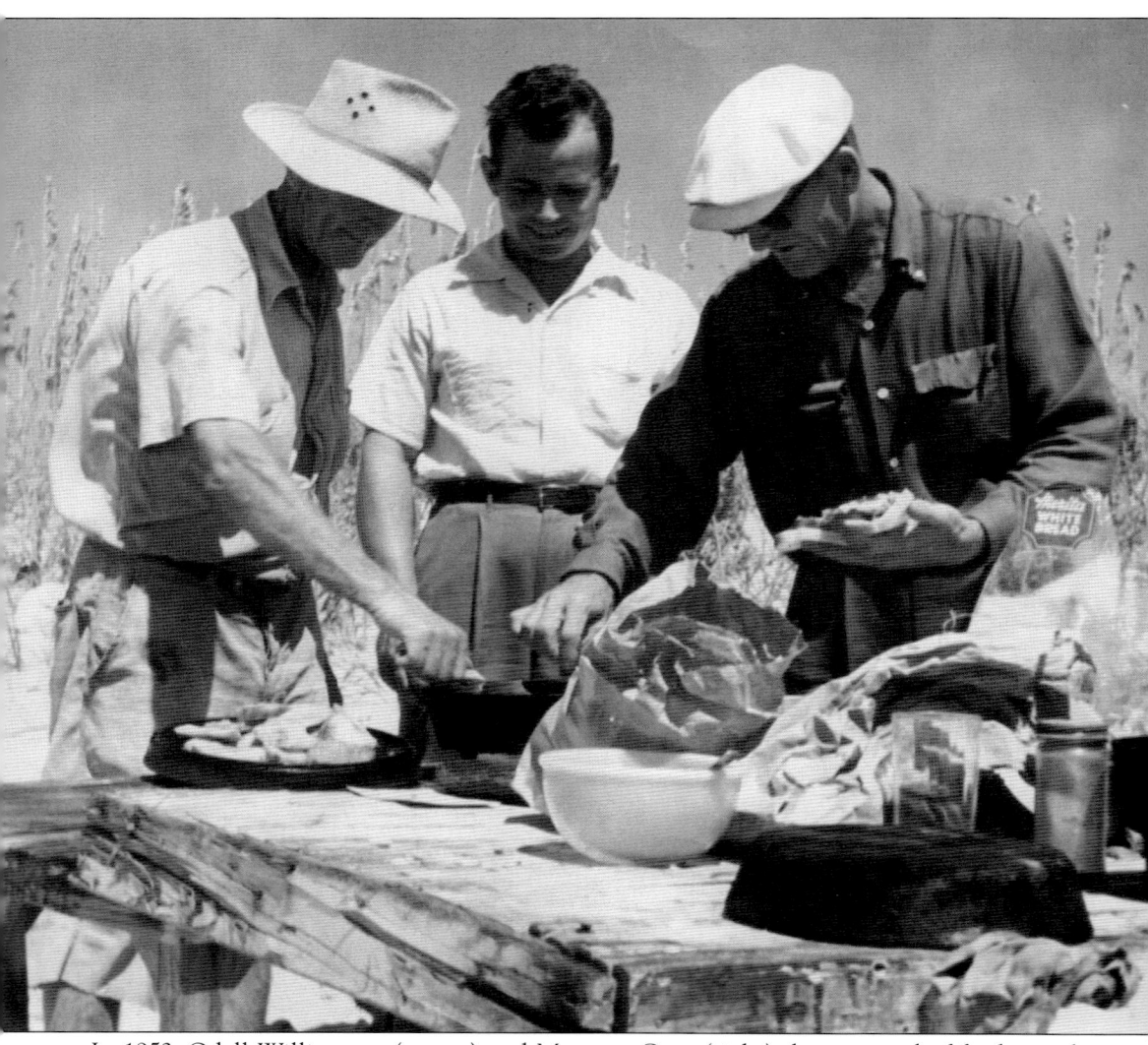

In 1953, Odell Williamson (center) and Mannon Gore (right) share a meal of fresh caught mullet on the beach with L.T. Hewitt as they discuss their plans for the development of the island. Williamson and Gore initially bought four miles of the island from John W. Rourk Jr. The Rourk family acquired the land from the Leonard and Stanley families in 1883. (Courtesy of Virginia Williamson.)

1.A.J.Van Hoef* 2.H.E.Mayberry† 3.R.A.Armistead† 4.F.W.Rivers 5.A.T.Santoro
6.J.G.Scharff 7.R.G.Starling 8.G.H.Strite 9.I.O.Stromberg 10.E.E.Tate 11.R.W.Tetzlaff
12.F.L.Thompson 13.A.C.Thomson 14.S.L.Tisdale 15.C.V.Utterback 16.J.F.Vaile
17.C.D.Vunck 18.C.J.Walker 19.R.C.Warner 20.W.W.Watson 21.J.E.Weatherly
22.C.R.Weinrich 23.R.H.Weston 24.I.Q.Wicker 25.V.R.Wiebusch 26.S.H.Williams
27.O.Williamson 28.F.L.Wilson 29.L.B.Yarbrough 30.A.T.York

 * In Charge † 1st. Alternate ‡ 2d. Alternate

 BATTERY OFFICERS' CLASS NO. 98.

Odell Williamson is seen with his Battery Officers Class No. 98. As a captain, Odell piloted 600 missions and earned the Air Medal for heroism eight times. (Courtesy of Virginia Williamson.)

Virginia Cox married Odell Williamson in 1940. At the end of World War II, Odell returned to Shallotte. The Williamsons opened Williamson Motor Sales, a Dodge and Plymouth dealership, with money that they had saved during the war. Odell also opened Shallotte Hardware Co., taking on Virginia's brother as a partner. (Courtesy of Virginia Williamson.)

The old Ocean Isle Beach Pavilion was operated by George and Rae Sloane and was the social center of the island. Ocean Isle Beach Pavilion had a real estate office, a small grill, and a large open area with a jukebox for dancing. This is the spot on the island where people came for any information they needed. (Courtesy of Tripp Sloane.)

On the ocean side of the pavilion, the commercial fishermen would fish daily and often share their catch. According to Rae Sloane, one of her children's best memories was of the older fishermen cleaning fish in the ocean, putting it on a stick, and cooking it over an open fire on the beach. (Courtesy of Tripp Sloane.)

Burris Stanley, the swing bridge operator, stands at the new Guy J. Myers Bridge prior to renaming it the Odell Williamson Bridge. There was a song released in March 2011 titled "Odell Williamson Bridge" recorded by the band Church Shoes. (Courtesy of Wendy Sheffield.)

The Ocean Isle Swing Bridge operated from 1959 until 1986, when it was replaced with the current bridge. After being decommissioned, the bridge was taken by barge into the Atlantic Ocean and sunk to create an artificial fishing reef. (Courtesy of Virginia Williamson.)

A proud fishing couple shows off their big catch at the Ocean Isle Pier in 1958. The Ocean Isle Pier is one of the oldest fishing piers along North Carolina's coast. (Courtesy of Virginia Williamson.)

In 1950, Odell Williamson and Mannon Gore built a four-car ferry that operated from 1950 to 1956. Mannon used his natural mechanical skills to design a ferryboat to cross the waterway quickly and efficiently. Prior to the ferry, the only access to the island was by boat. (Courtesy of Virginia Williamson.)

Here, the Ocean Isle Beach ferry is leaving the mainland from Brick Landing. By 1956, the four-car ferry had been replaced with a state-owned two-car ferry. The first ferry operators were Clyde Stanley and Will Gurganus. The ferry operated seven days a week. (Courtesy of Virginia Williamson.)

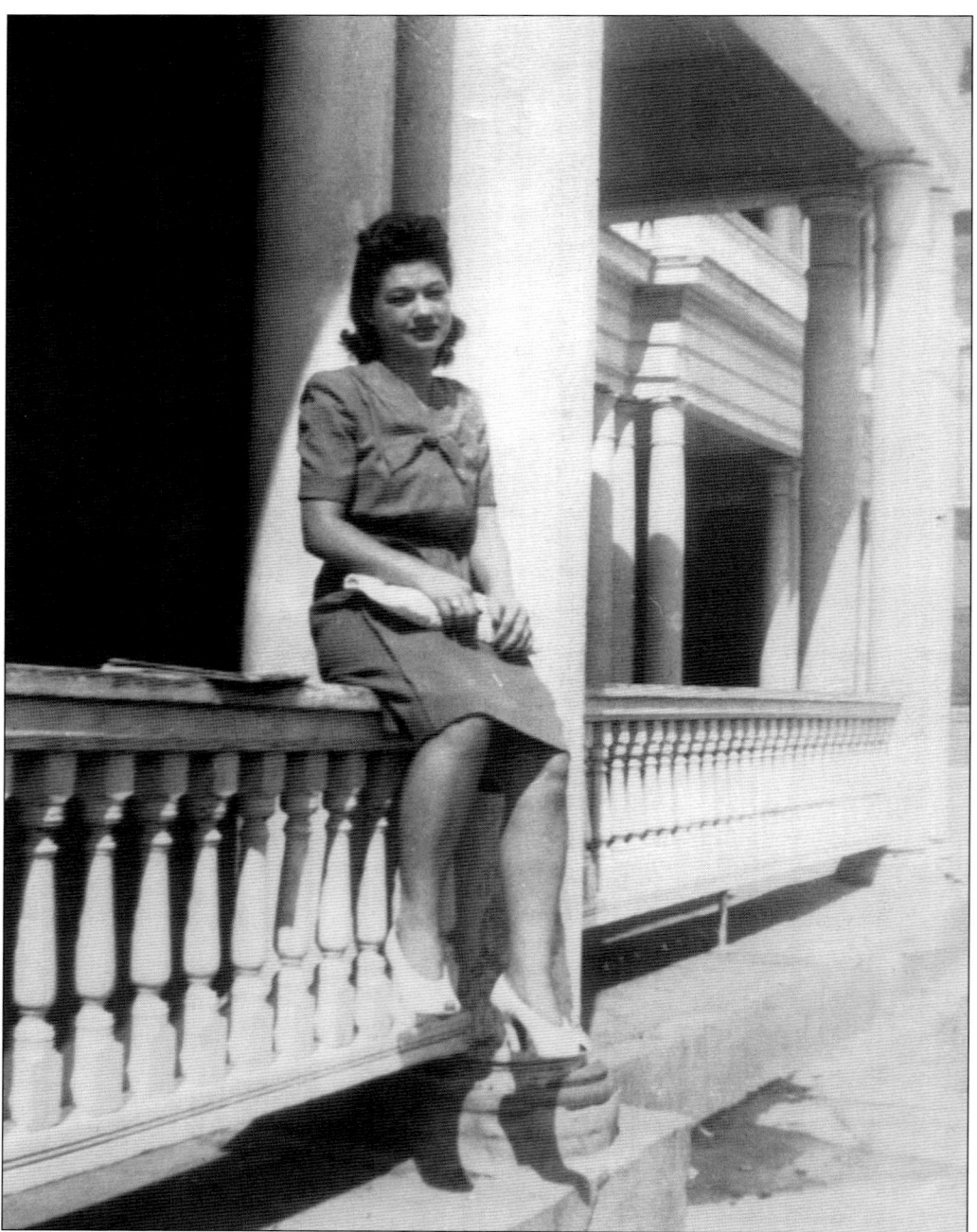

Virginia Cox Williamson was born in Loris, South Carolina, to Olin and Martha Cox. She was one of eight children, and she worked alongside her siblings on their parents' farm. Virginia graduated from Loris High School and attended Marlboro Business School. Her entry into business was working at her uncle's store in Hickman's Crossroads. It was through a chance encounter that she met the love of her life, Odell Williamson, there. (Courtesy of Virginia Williamson.)

Herbert Goltson and Warren Hewitt are standing at the Gause Tomb. In reference to the cemetery, the following is from *Comprehensive Historical/Architectural Site Survey of Brunswick County, North Carolina*, prepared for Brunswick County commissioners in 2010: "The Gauses were another influential planter family of the first half of the nineteenth century, and two burial sites attest to their wealth and prestige. The impressive Gause Tomb near Ocean Isle Beach may date to the 1830s. The tomb is rectangular in form, with stepped sides and a cambered brick-paved roof supported on the interior by vaulting and a central brick pier. An obelisk and memorial plaque is reported to have formerly been positioned above the jack-arched entry. Modestly scaled brick tombs, more typical of the ones constructed for the County's planter elite, survive in deteriorated condition in the Gause Cemetery in Sunset Beach. One of the tombs has a mortar inscription block, which appears to have an almost illegible 1830s date that was part of a barrel vault or rounded cresting." (Courtesy of Virginia Williamson.)

Prior to Hurricane Hazel, Ocean Isle Beach had with mounds of sea oats and sand dunes. Gause Hill, where the Williamson family home sits, was reported to be one of the highest dunes on the East Coast prior to Hurricane Hazel. (Courtesy of Virginia Williamson.)

Ocean Isle Beach in 1953, before Hurricane Hazel struck, was a sandy, white beach with lush vegetation. As Hazel approached Ocean Isle, 11 people on the island took shelter hoping to ride out the storm. As the water rose, they fled to a nearby truck. The men were on the outside of the truck and tried to keep it upright with the women and children inside, but Hazel's fury tore the truck from their hands. Nine of these eleven, which included Odell Williamson's sister and most of her family, were the only people to perish on Ocean Isle that day. Odell walked the island from end to end for a week looking for his sister Madeleine and not speaking to anyone. Her body was never recovered. (Courtesy of Virginia Williamson.)

The Ocean Isle Beach Pier was completed in 1957 and originally run by the Williamson family. Virginia Williamson handled the day-to-day operations of the pier for several years after it was opened. (Courtesy of Virginia Williamson.)

Shown here is the Ocean Isle Beach Pier. The pier was designed and built by Odell Williamson, with each and every piece of wood inspected as it was being constructed. (Author's collection.)

George A. Sloane served with the Merchant Marines for two and a half years. Odell Williamson knew that this young man was just what a burgeoning island needed. George had a mind for business and a personality for sales—a combination that help to build his family empire. (Courtesy of Rae Sloane Cox.)

Rae Sloane was one of the first women involved in real estate transactions in North Carolina. Potential buyers of lots were often surprised when Rae negotiated the price and contracts with them. On one occasion, a group of investors purchased several lots and made the remark that they had never spent that much money with a woman handling the business. Several years later, she handled the sale of the same lots, and the investors were extremely pleased with their double return on their investment. (Courtesy of Rae Sloane Cox.)

Shown here is the Ocean Isle Motel in 1960. The Sloane family moved into an apartment in the motel. Initially, the lodging contained only 6 rooms, and it was later expanded to 17 rooms. (Courtesy of Tripp Sloane.)

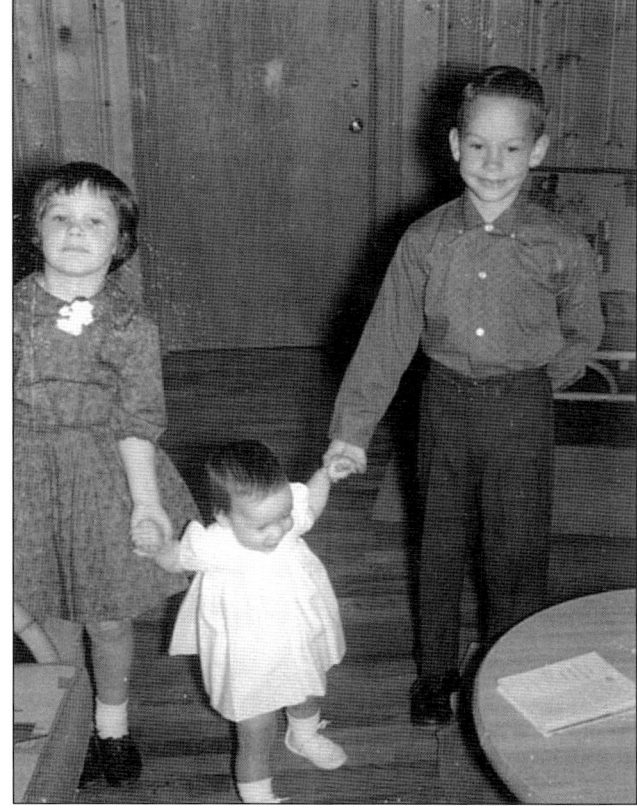

Debbie (left), Pamela (center), and George A. "Tripp" Sloane III attended school on the mainland. At the beginning of their formal education, Debbie and Tripp had to ride the ferry across the waterway to attend school. As part of the only family on the island the first few years, they spent a lot of time exploring the island. (Courtesy of Rae Sloane Cox.)

In 1969, George A. Sloane was the mayor, operated the liquor store, and collected the garbage on the back of a flatbed all in the same year. (Courtesy of Tripp Sloane.)

Willa Rae Sloane and George A. Sloane are shown here. Married on January 27, 1949, the Sloanes were the first permanent residents of Ocean Isle Beach. (Courtesy of Tripp Sloane.)

George A. Sloane received his business degree from the University of South Carolina. (Courtesy of Rae Sloane Cox.)

Tripp Sloane graduated from Shallotte High School in 1970. After attending the University of North Carolina at Chapel Hill for one year, he decided that he would help his mother with the business after his father was tragically killed in an automobile accident in July 1971. (Courtesy of Rae Sloane Cox.)

Along with Gene Hardee, George A. Sloane owned and operated the Breakers in the mid- to late 1960s. Pamela Sloane operated the bingo room. Tripp and Debbie ran the grill and game room, and according to their mother, gave away more hamburgers to friends than they sold. (Courtesy of Tripp Sloane.)

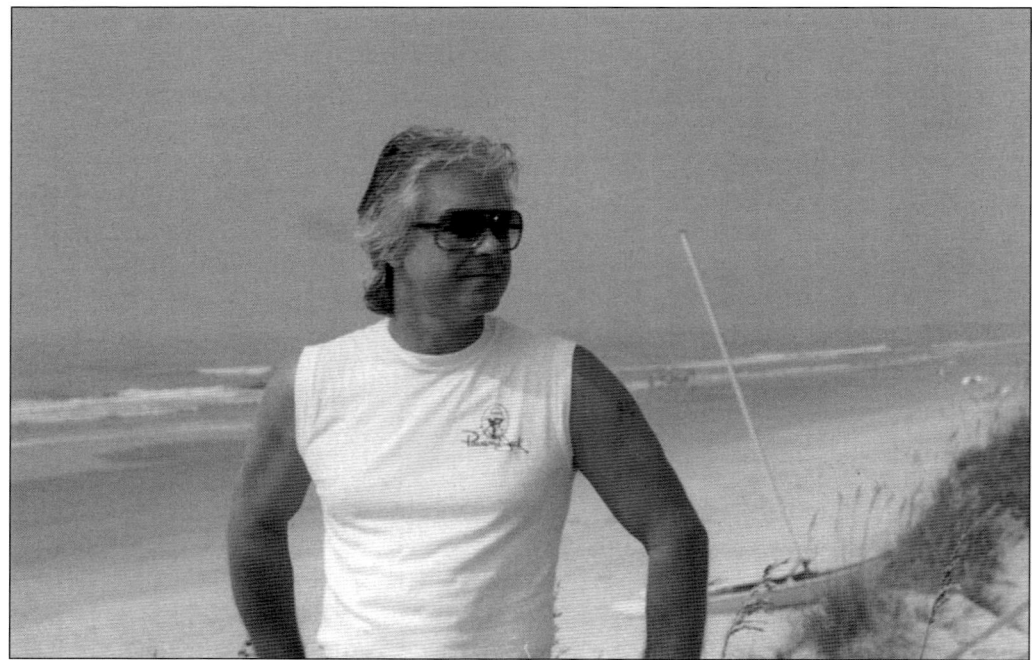

Gene Hardee is seen taking a beach break in 1973. Hardee and George Sloane built the Breakers in late 1967 and opened it for the 1968 season. Currently, Hardee owns and operates the business. (Courtesy of Rae Sloane Cox.)

Parker and Naomi Phillips owned the first miniature golf course on the mainland. They opened the course in the mid-1960s, and as a young boy, Tripp Sloane would clean the golf course in exchange for playing. (Courtesy of Tripp Sloane.)

The Sunnyside School was completed in 1915 and has gone on to serve countless numbers of children in the area. Even after the Shallotte High School building was erected in 1927, Sunnyside was allowed to remain on the grounds and used for classrooms throughout the remaining life of the newer building. Shallotte High School was closed and razed in 1972, and Shallotte Middle School was built on the site. Sunnyside was moved to the northeastern intersection of NC Highway 130 West and Main Street. (Author's collection.)

The pavilion is shown here in 1955. Local fishermen would fish off of the beach with nets. There would be one man who was the lookout, scouting for schools of fish. The fishermen would run the net in from the fish and pull them onto the beach. They would sell the fish from the pavilion. White flags would fly from poles to let people on the mainland know the fishermen had a big catch and were open for business. (Courtesy of Tripp Sloane.)

Affectionately nicknamed "Jug," the Republic P-47 Thunderbolt was one of the most famous fighter planes of World War II. The P-47 developed as a heavyweight fighter and made its first flight on May 6, 1941. In April 1943, the Thunderbolt flew its first combat mission. Used as both a high-altitude escort fighter and a low-level fighter-bomber, the P-47 quickly gained a reputation for ruggedness. More than 15,600 Thunderbolts had been built by the end of World War II. (Courtesy of Carolinas Aviation Museum.)

This is a photograph of the P-47D Thunderbolt crash site, when a P-47D landed on Ocean Isle Beach due to fuel exhaustion during a training mission during World War II. Records show that Lt. Robert Boyd went down on June 29, 1944, at 16:15 hours. Lieutenant Boyd was not injured during the crash. Before it could be recovered, a storm came in and waterlogged the aircraft. The Army Air Forces removed all usable parts and buried the wreck on the beach. In 2000, a hurricane uncovered the aircraft. Here, Stuart Matthews discusses with onlookers the wing, fuselage, and supercharger that were found nearby. (Courtesy of Stuart Matthews.)

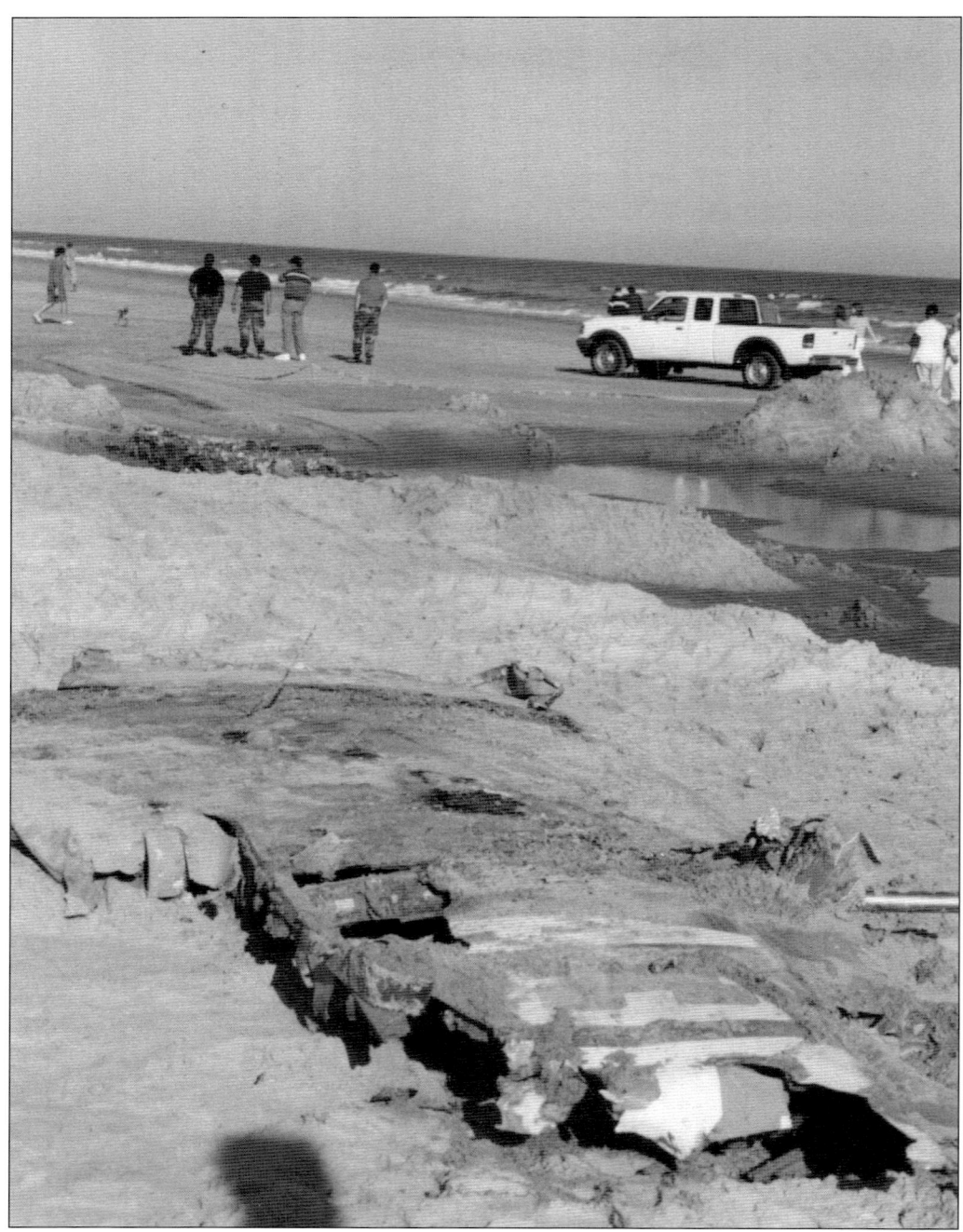

A local newspaper originally incorrectly identified the plane as an F4 Wildcat. Stuart Matthews, an aircraft mechanic, contested the information. He determined it was a P-47 Thunderbolt due to the landing gear, the .50-calibre machine gun in the wing, and the information on the wing data plate. (Courtesy of Stuart Matthews.)

Shown in this view looking toward the ocean is the back of the Williamson home. Odell Williamson purchased the McLamb residence in 1955 after it survived Hurricane Hazel. The house was tossed over half a mile from its original location, and Williamson had it moved back to its oceanfront lot. (Courtesy of Virginia Williamson.)

The Williamson was home built in 1964 on Gause Hill. The hill was originally part of the William Gause Plantation that stretched from the ocean to several miles inland. This is the highest point on the island and was the only spot on the island that Hurricane Hazel did not cover with water. A Coast Guard station was located on Gause Hill during World War II. (Courtesy of Virginia Williamson.)

The Ocean Isle Beach Miniature Golf Course was course built in 1979–1980. Dr. Sonny Nixon and N.F. Nixon owned 50 percent of the business, and Odell Williamson owned the other 50 percent. The first course was flat. Williamson purchased the Nixons' 50 percent and updated the course. He added hills, the river, thatched-roof huts, and palms. It was renamed River Country of Ocean Isle and is managed by Ray Little and remains under the ownership of the Williamson family. (Author's collection.)

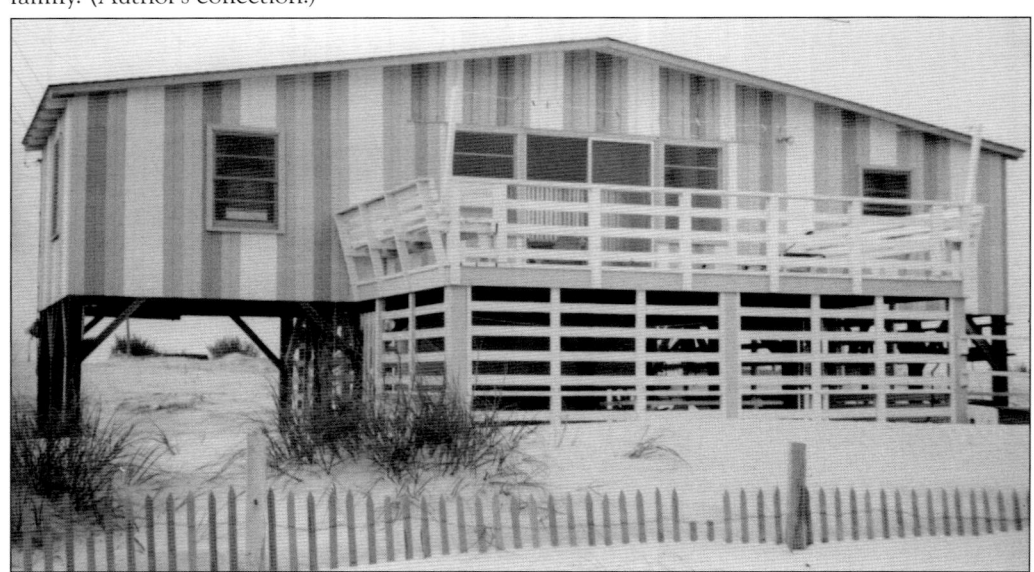

Richard Jennings built the Camp Atlantic Boys Camp in 1965. It was the first and only boys' camp on the island and had a large dining hall and sleeping quarters. Richard was the camp director and planned activities for the boys all summer. Camp Atlantic was later torn down, and a new house was constructed in its place. (Courtesy of Tripp Sloane.)

These are the first canal lots in 1960. In 1960, Odell Williamson took to his construction equipment and began digging canals. Before digging the canals, there were some flooding issues and a very bad mosquito problem. Digging the canals helped to combat the mosquito problem, and the new canal owners had easy access for their boats. (Courtesy of Virginia Williamson.)

Canal lots sold for $2,500 in 1963, and oceanfront lots sold for $4,000. Odell Williamson strategically planned the number and location of each canal as he worked on the island's infrastructure. (Courtesy of Tripp Sloane.)

The Ocean Isle Beach Board of Commissioners is a six-member board, which consists of the mayor and five board members. According to Virginia Williamson, they did conduct some of their meetings on the beach. (Courtesy of Virginia Williamson.)

The 1965 Ocean Isle Beach Board of Commissioners includes, from left to right, (first row) Virginia Williamson and Homer Johnston; (second row) J.C. Fortson, Dr. R.B. McKnight, Virginia Ervin Horne, and Watt Huntley. (Courtesy of Virginia Williamson.)

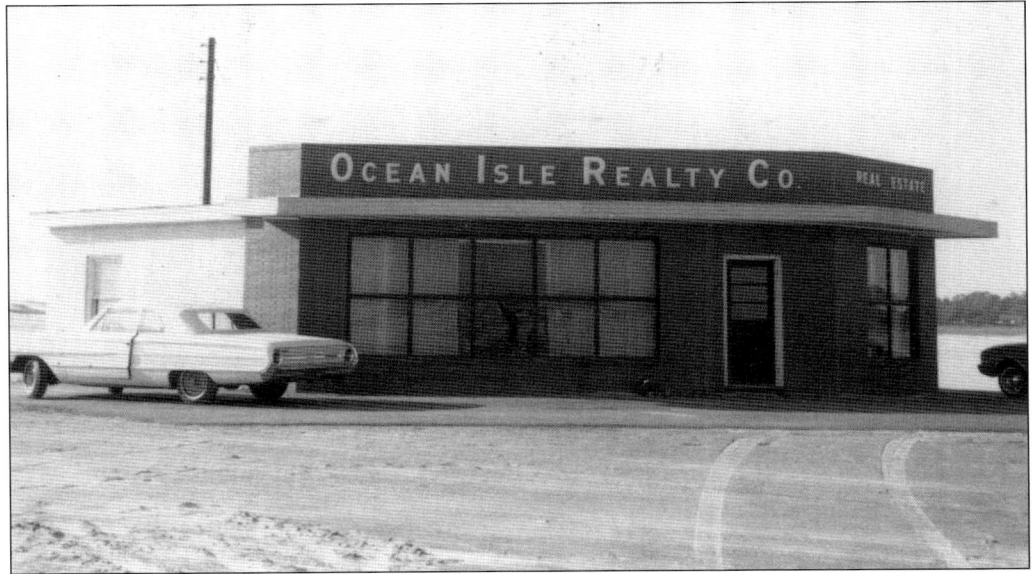

During World War II blackout conditions in 1942, the HMS *St. Cathan* and Dutch freighter *Hebe* collided off the coast of Ocean Isle. Ships during World War II would travel at night with no lights on to avoid being torpedoed by German U-boats. The shipwrecks are located less than a mile apart off the Ocean Isle Beach coast. (Courtesy of Virginia Williamson.)

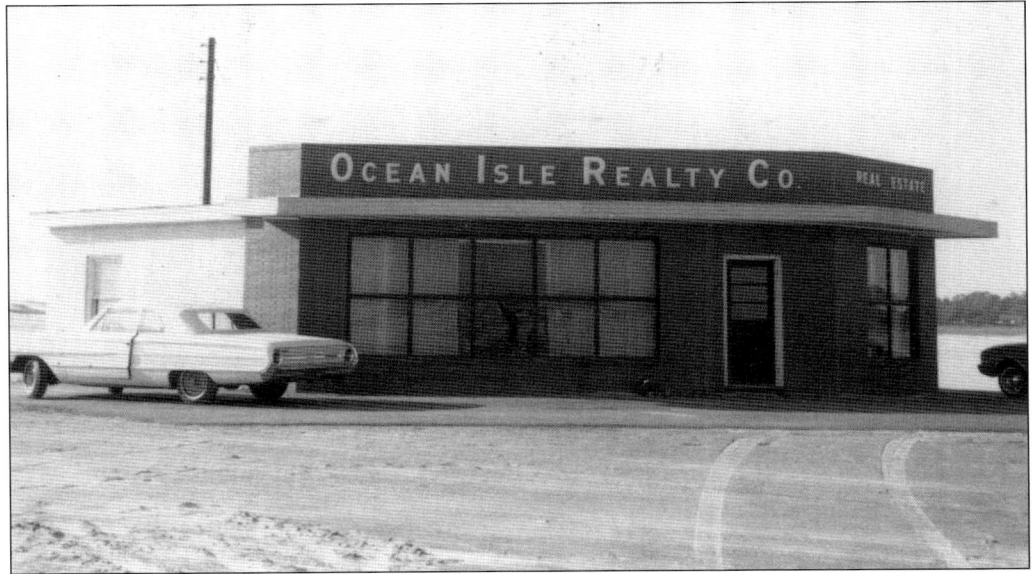

The Williamsons' first real estate office was built in 1957, and it currently operates as a private office. Rae Sloane worked out of this office for about a year alongside Odell and Virginia. (Courtesy of Virginia Williamson.)

Construction of the Ocean Isle Beach Pier began in 1956 by Odell and Virginia Williamson and was completed in 1957. The Williamsons have been a vital part of the pier's success through the years. Currently, Will Long operates the pier. (Courtesy of Virginia Williamson.)

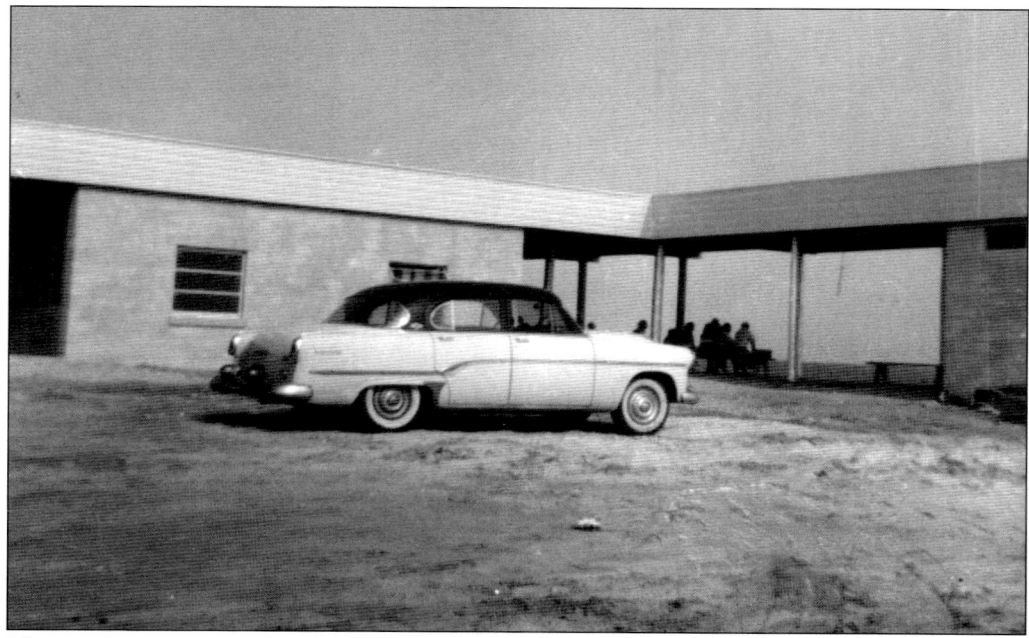

The pavilion was a weekend date spot for the locals as well as the vacationers on the island. The jukebox provided the music as the young people danced the night away. According to one Shallotte resident, the pavilion was the place to be on the weekends—with good food, good music, and good stories. (Courtesy of Tripp Sloane.)

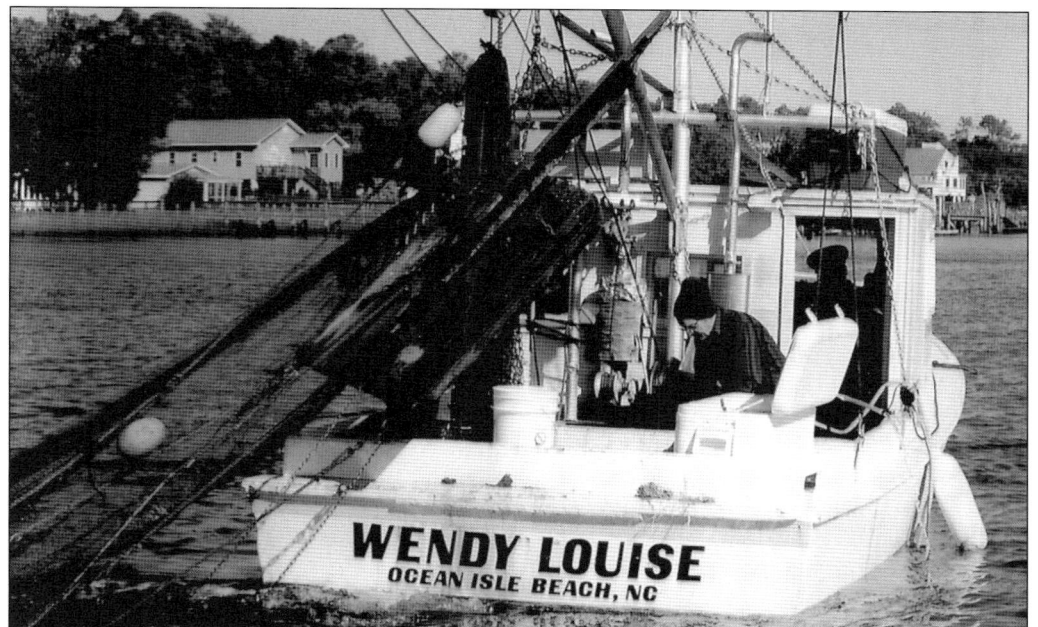

William "Billy" Carter, aboard the *Wendy Louise,* heads out to catch fresh fish and shrimp to be sold at Sheffield's. The boat is named after his daughter Wendy and granddaughter Louise. Carter also worked with Odell Williamson when the canals were dredged. (Courtesy of Wendy Sheffield.)

Louise Sheffield is shown here with her grandfather William "Billy" Carter and dog Coy. Louise is the third generation to take the helm at Sheffield's. She and her brother Johnathan work alongside their parents, Wendy and John Sheffield. (Courtesy of Wendy Sheffield.)

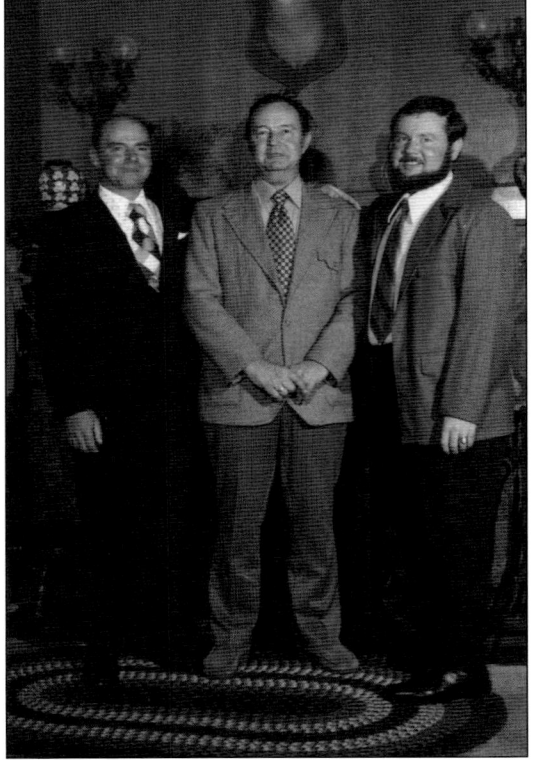

Iconic Sheffield's opened in 1967. In 1985, Sheffield's hosted the first king mackerel tournament in the area, the Ocean Isle King Mackerel Tournament. It was a huge success, and the field of entrants grew exponentially. Eventually, the tournament was handed over to the South Brunswick Islands Chamber of Commerce and renamed the US Open King Mackerel Tournament. (Courtesy of Tripp Sloane.)

The original owners of Sheffield's— Jimmy Sheffield Jr. (left), James Wesley Sheffield Sr. (center), and John Calvin Sheffield—are seen here. All three were involved in the design and construction of Sheffield's. (Courtesy of Wendy Sheffield.)

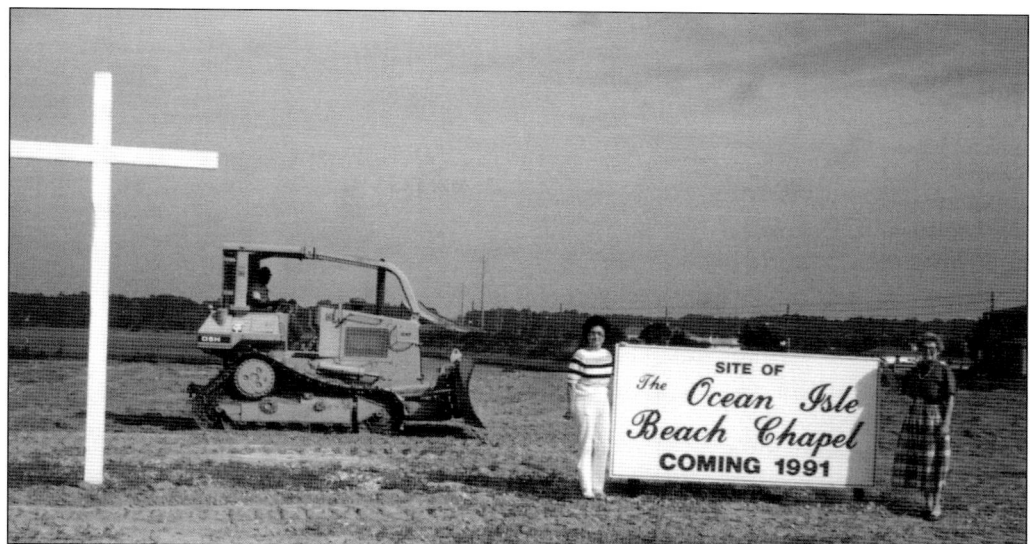

Work began on the chapel in 1990. Virginia Williamson (left) and Lomie Lou Cooke stand by the new sign as Odell Williamson works on leveling the lot. The Ocean Isle Beach Chapel was completed in 1991 and was ready to take the service over at the beach and has continued until the present. Services on the strand are on Easter Sunday and then from Memorial Day to Labor Day at 8:30 a.m. on Sundays. The Ocean Isle Beach Chapel has services every Sunday morning through the year at 9:30 a.m. with a different minister each Sunday. The chapel does not have membership, and the doors are opened to all. (Courtesy of Virginia Williamson.)

Odell Williamson inspects the foundation of the Ocean Isle Beach Chapel. Virginia Williamson placed verses of scripture inside almost all the foundation blocks. (Courtesy of Virginia Williamson.)

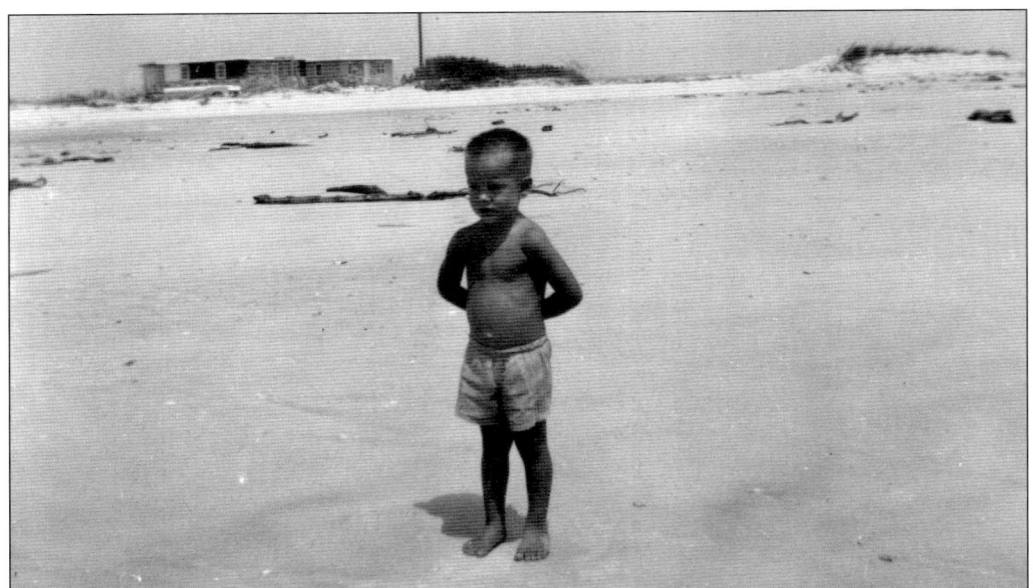

The Sloane family were the only permanent residents on the island for eight years. The population of Ocean Isle Beach from 1955 to 1963, according to the *World Book Encyclopedia*, is listed as four, which includes George and Rae Sloane and their two children, Tripp and Debbie. (Courtesy of Tripp Sloane.)

Sisters Debbie (left) and Pamela Sloane are pictured. Debbie works alongside her brother Tripp in the family real estate business. She has also served as mayor of Ocean Isle Beach since 2003. (Courtesy of Rae Sloane Cox.)

The Williamson family often invited friends aboard their amphibious vehicle, affectionately named *Duck*, for an adventure at sea. (Courtesy of Virginia Williamson.)

In the 1920s, Tubbs Inlet was used to smuggle liquor into Brunswick County from Canada and the Bahamas. Tubbs Inlet has periodically been dredged for erosion control purposes to redirect channels away from buildings, and in 1970, it was relocated with artificial closures. (Courtesy of Tripp Sloane.)

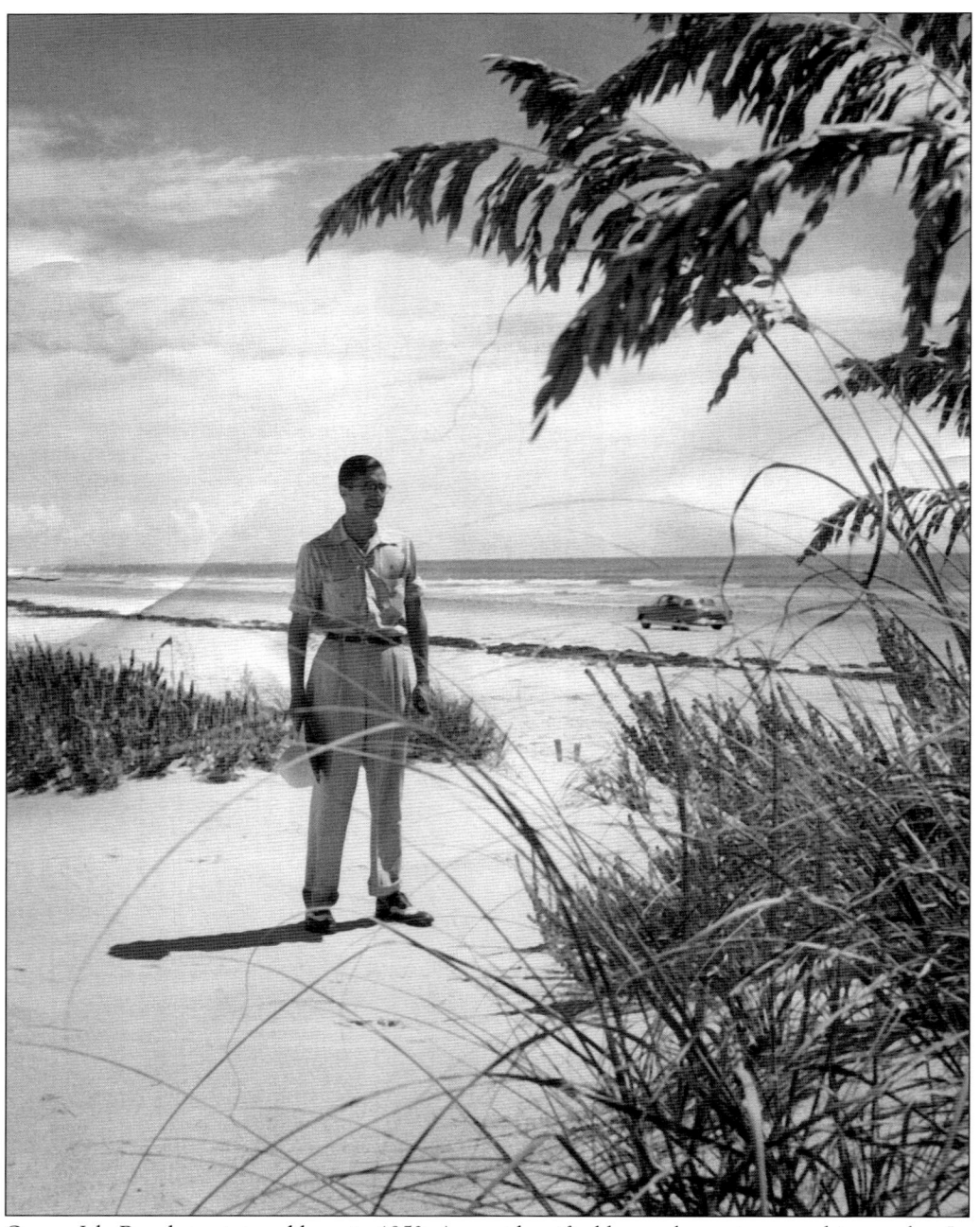

Ocean Isle Beach is pictured here in 1953. An unidentified happy buyer inspects his new lot. In 1954, oceanfront lots sold for $1,000, second row for $500, and third row for $200. (Courtesy of Virginia Williamson.)

Odell and Virginia Williamson were members of Camp United Methodist Church in Shallotte. In the 1960s, the minister would have an early worship service on the beach on Sunday mornings before his service in Shallotte. Murry DeHart led the services at Ocean Isle from 1964 to 1968. (Courtesy of Virginia Williamson.)

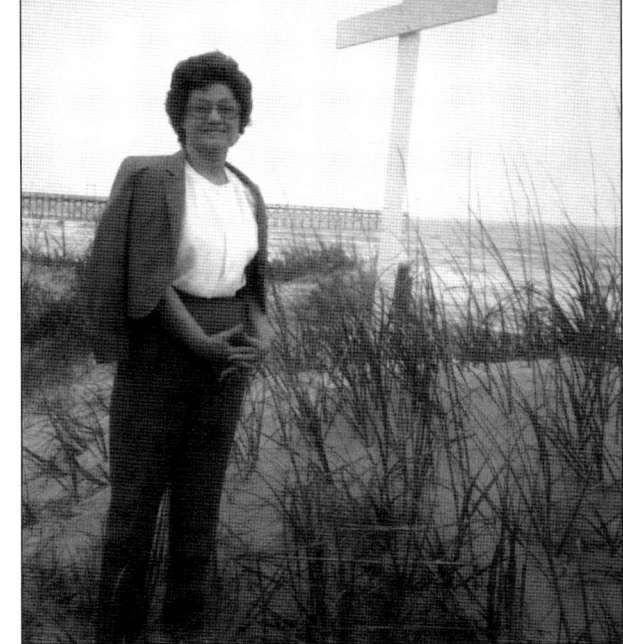

Virginia Williamson prepares for an early-morning service in 1964. She would close the pier on Sunday mornings so that the employees could attend the services on the beach. She and her husband always kept faith in the forefront. (Courtesy of Virginia Williamson.)

Pictured here is the Ocean Isle Motel in 1957. In 1955, George A. and Willa Rae Sloane moved to Ocean Isle Beach and were the first full-time residents. Shortly thereafter, they opened an oceanfront motel, where they lived and operated a real estate office. (Courtesy of Tripp Sloane.)

This is a photograph of the Ocean Isle Inn. Today, this new 75-room, oceanfront motel stands where the original motel was and is one of several successful businesses the Sloane family owns and operates. (Author's collection.)

This aerial photograph of the canal lots was taken for a survey for the North Carolina Department of Transportation. Marvin Stanley served as chief of police of Ocean Isle Beach for 15 years and was instrumental in the construction of the town's canal system. Later, he served as town commissioner of Ocean Isle Beach and was owner-operator of the Brick Landing Fish Camp. (Courtesy of Virginia Williamson.)

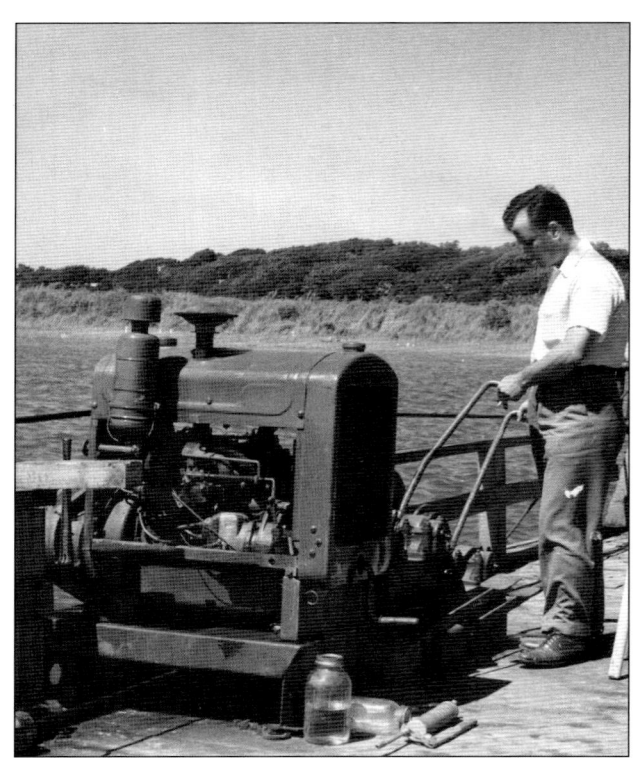

Odell Williamson is seen here operating machinery on the canal. Every day, he was up at 7:00 a.m. to get ready for work. According to Virginia, Odell always said, "You need to eyeball everything you do." He was involved in every aspect of the projects he worked on. (Courtesy of Virginia Williamson.)

Odell Williamson supervises the canal work. He made certain to personally oversee all of his the projects and often worked on construction sites in a suit and tie with his sleeves rolled up. (Courtesy of Virginia Williamson.)

Here, Odell meets with his planning team as the men map out the new Ocean Isle Beach Golf Course in 1973. He was involved in the development of six additional golf courses, including the Pearl Courses, Angels Trace, Ocean Harbour, and Marsh Harbour. (Courtesy of Virginia Williamson.)

The Sloane family built and moved into an apartment in the Ocean Isle Motel. The initial design had 6 rooms, and it was later expanded to 17. Rooms rented from $8 to $20. Renters had to come across on the old ferry, and the very first renter got stuck in sand between the ferry and motel. George Sloane Jr. had to use a four-wheel-drive truck to pull the vacationer partway to the motel; he had to help the man again when it was time for him to leave. (Courtesy of Tripp Sloane.)

In the 1970s, Helen and Miller Pope discovered Ocean Isle Beach. It was mostly undeveloped, with long stretches of windswept dunes crested by waving sea oats. They decided to retire to Ocean Isle and start a business. Property was acquired and the Trade Winds, the East Winds, and the Seawinds were built. It was a natural to call the resort assemblage the Winds. Miller had originally wanted to name the resort Poseidon, but received a quick veto from Helen. (Courtesy of Gary Pope.)

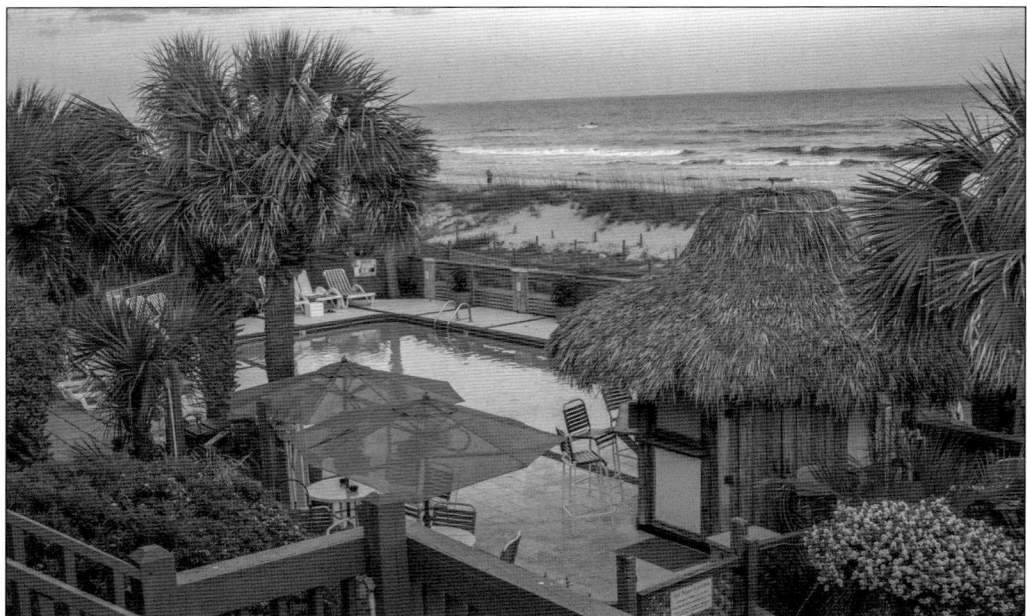

The Winds continues to be family owned and operated with Miller and Helen's son Gary and daughter Debra managing the daily operations. Debra and Gary have positive changes in mind but plan to keep the retro look of the charming Winds. (Courtesy of Gary Pope.)

Pictured here is the Brick Landing Plantation Golf Club in 1987. William Gause Sr. purchased land in 1751 in Brunswick County and established the Gause Plantation overlooking a channel with marshland. This marshland is known today as Ocean Isle Beach. His turpentine- and tar-shipping trade allowed him to increase his plantation to several thousand acres. Ships would come into Tubbs Inlet during high tide to unload their cargo and then load up and head back to England. Bricks were shipped from England in order to build the Gause tomb and several other buildings on the property, resulting in the property being named Brick Landing. (Courtesy of Brick Landing Plantation Golf Club.)

Imagine a man fishing on the beach. A young boy walks up to him and asks, "What kind of fish is that, mister?" Thus began Stuart Ingram's vision of sharing his knowledge of nature and science by creating a museum. The Museum of Coastal Carolina opened on May 25, 1991, in Ocean Isle Beach. It is the only museum located on a North Carolina barrier island. The Williamson family donated the land for the museum, and the Ingram family made an undisclosed, sizable donation. (Courtesy of the Museum of Coastal Carolina.)

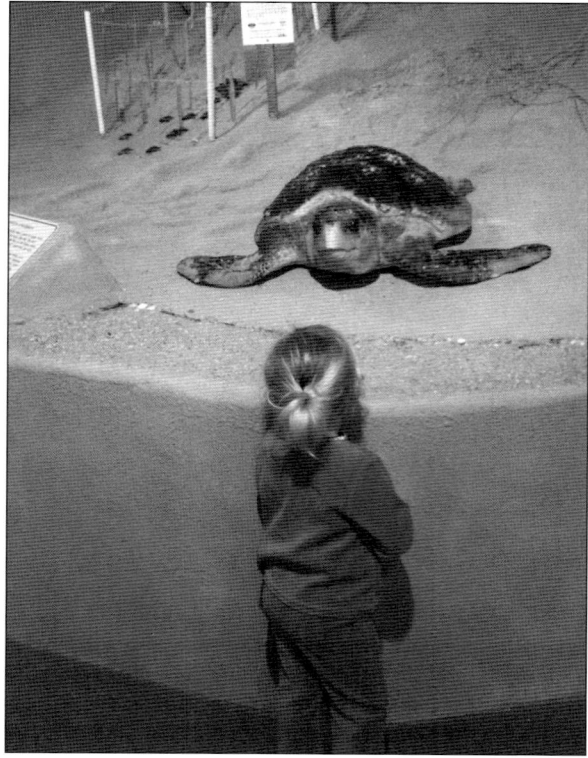

This is a loggerhead sea turtle exhibit. Activities include summer afternoon and evening family programs, lecture series, and outdoor classrooms. Here, people can learn about the natural history, wildlife, environment, and culture of coastal Carolina. (Author's collection.)

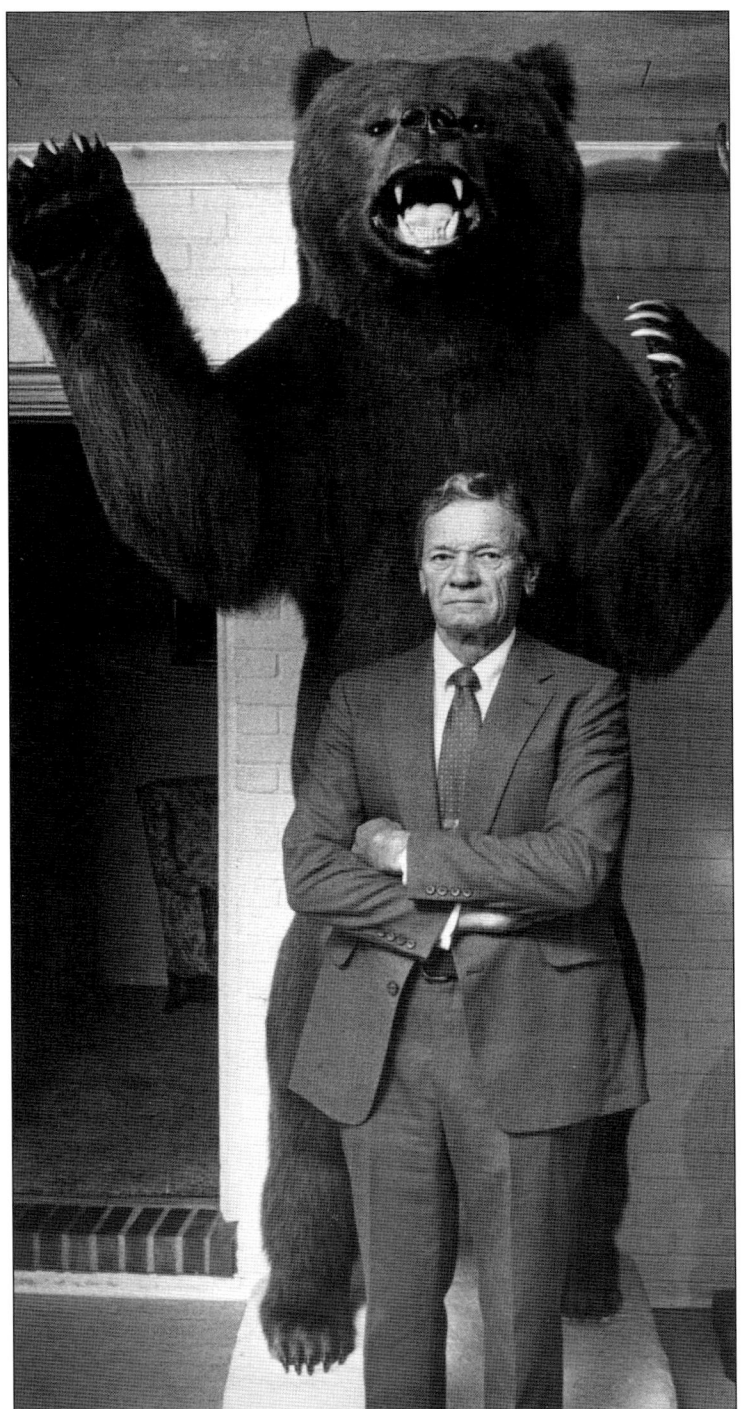

"Big" Stuart Ingram is shown here with his part of his wildlife collection. He donated a portion of the collection to the Ocean Isle Museum and the rest to Discovery Place in Charlotte, North Carolina. (Courtesy of Leigh Ingram.)

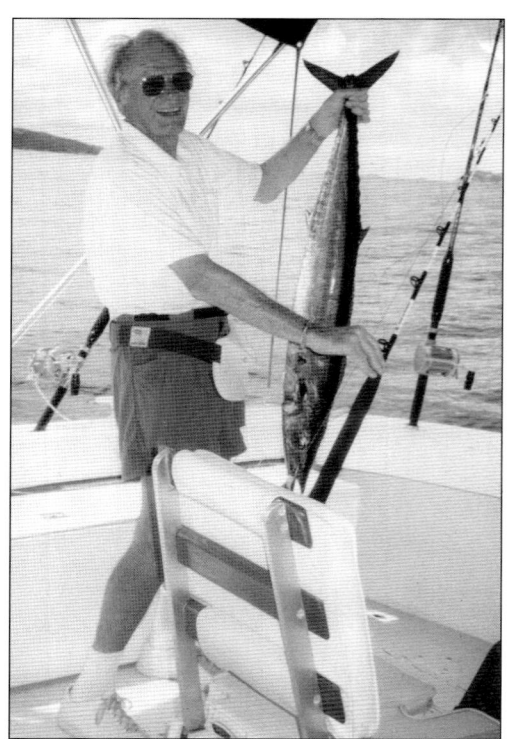

Stuart Ingram met Louise Reynolds at Duke University, and they discovered their mutual love of nature. They were married in 1948. (Courtesy of Leigh Ingram.)

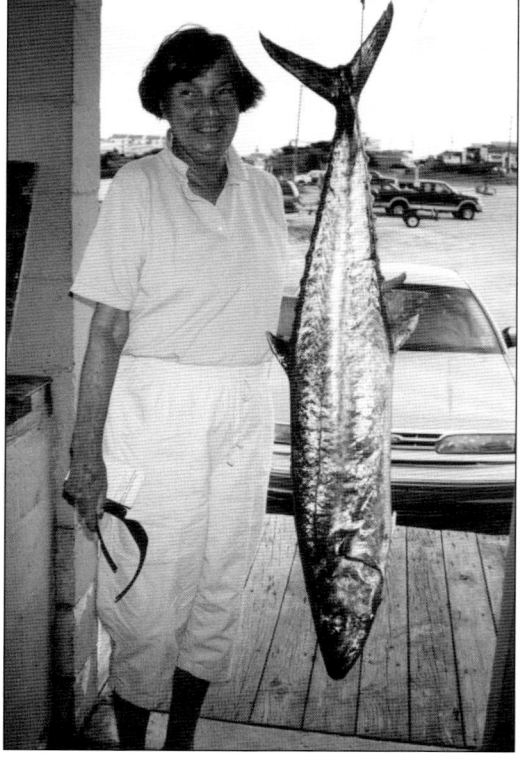

Stuart and Louise Ingram discovered Ocean Isle Beach in 1957 and spent two weeks there every summer until 1983, when they became permanent residents. Louise Ingram is shown here with a citation-winning catch at Ocean Isle. She and Stuart spent most days sharing their love of nature with each other and their knowledge of science with the local community. (Courtesy of Leigh Ingram.)

The Ocean Isle water slide was built and opened by the Williamson family in the 1970s and closed in the 1990s. (Author's collection.)

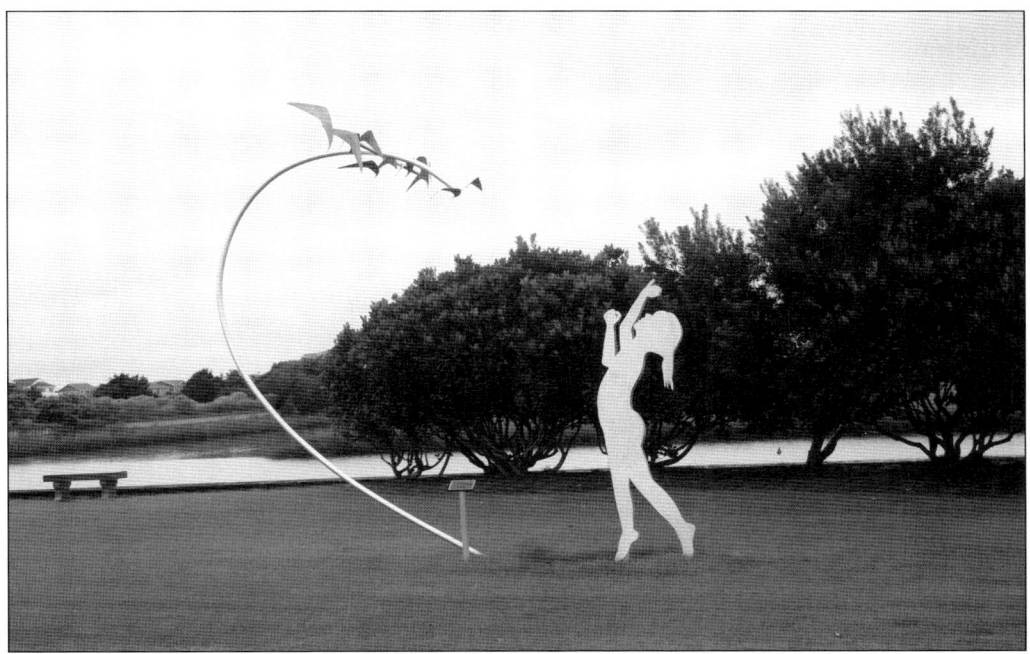

Sculptor Thom Seaman's *Lillah* greets those crossing the bridge onto Ocean Isle Beach. It was placed there in 2003 in commemoration of the Ocean Isle Beach Property Owners Association's 20th anniversary. (Author's collection.)

Odell Williamson Bridge

November 23, 2002

Odell Williamson, always thinking years ahead, made a tactical decision to build Four Mile Road from the center of Ocean Isle Beach. Although it took several years of hard labor and personal funds, Odell was able to take to road to Highway 17. (Courtesy of Virginia Williamson.)

Shown here is Big Nell's Pit Stop in 1980. True Southern charm is dished out at this classic restaurant run by Al Harrelson. It is only open for breakfast and lunch and is famous for its Pit Stop breakfast and friendly staff. Having a meal or two at Big Nell's is a family tradition for many vacationers. (Author's collection.)

Pictured here in 1984 is Gloria Hillenburg, the original "turtle lady" of Ocean Isle Beach and the founder of the first turtle watch program on the island. She worked the program alone for almost four years, walking seven miles up and seven miles back, sometimes two or three times a day, to check on the nests that were on the beach. (Courtesy of Gloria Hillenburg.)

This is an image of the original turtle patrol in 1996. The original turtle watch program trained volunteers to monitor sea turtle nesting activities. This was one of the most dedicated groups of volunteers in the program. The current Ocean Isle Beach Sea Turtle Protection Organization is an all-volunteer program coordinated by Deb and Jim Boyce. (Courtesy of Gloria Hillenburg.)

Located inside the small general store, the Ocean Isle Beach seasonal post office operated from 1962 to 1996. The first postmistress was Betty Causey. (Courtesy of Tripp Sloane.)

The Islander Restaurant was at onetime the finest restaurant on the island. According to the locals, everyone would eat there while on vacation. One summer, it was leased by two ladies who not only extended the menu but also added weekend parties complete with live bands. (Courtesy of Tripp Sloane.)

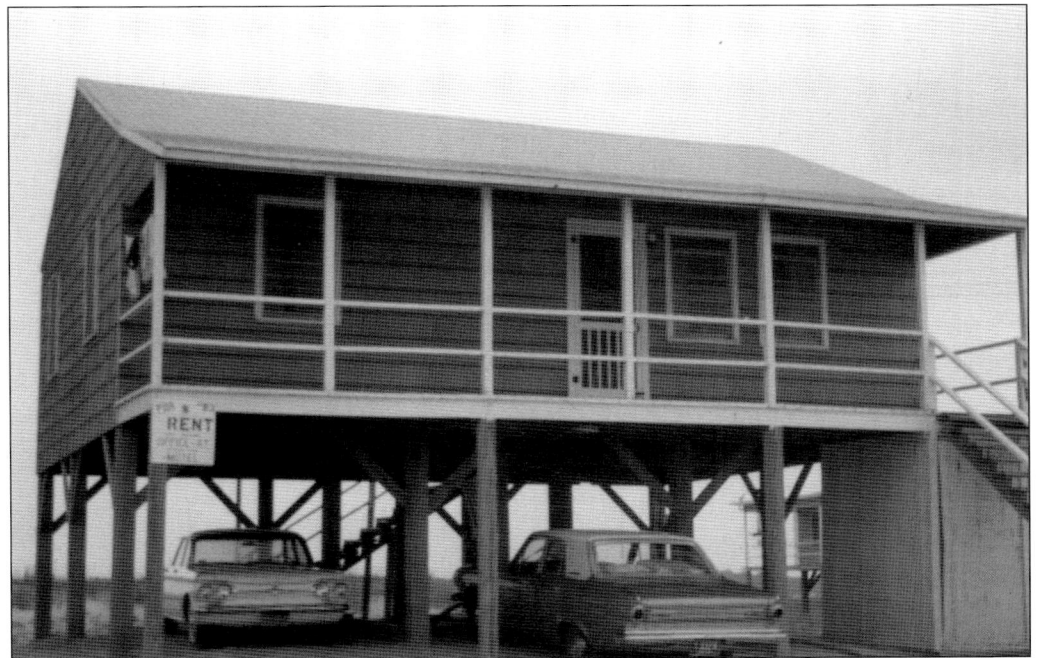

Oceanfront lots sold for $2,500–3,000 in 1960. Prices have certainly gone up in recent times! (Courtesy of Tripp Sloane.)

John and Lomie Lou Cooke, who had owned property and vacationed at Ocean Isle since 1959, founded Cooke Realty in 1970. Oceanfront lots sold for $12,000 in 1970 and for $25,000 in 1972—more than doubling in price in just two years. (Courtesy of Tripp Sloane.)

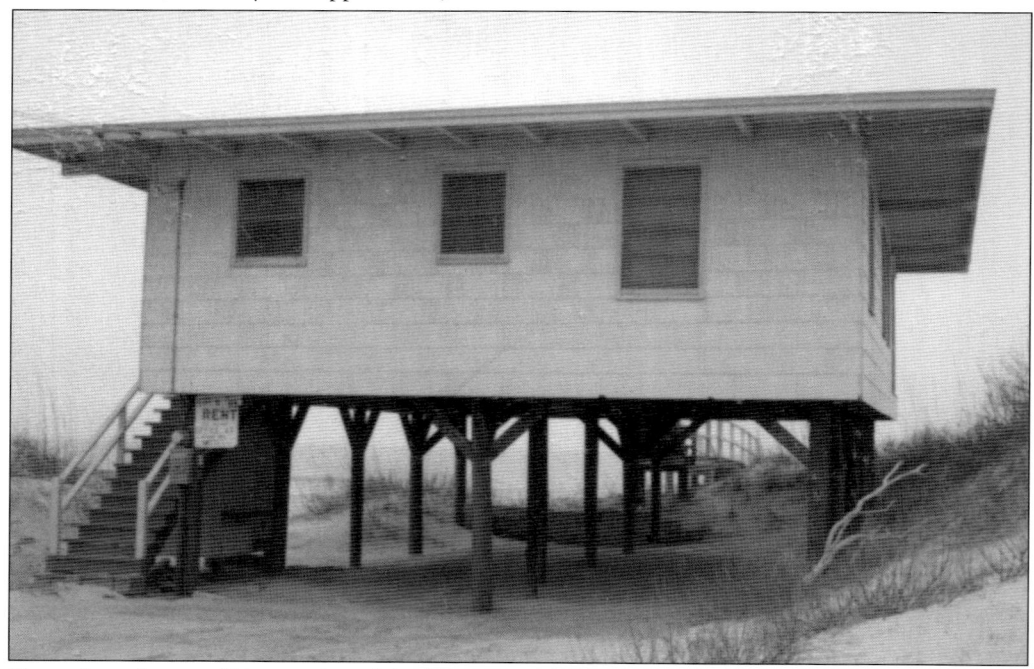

Canal lots sold for $1,500 in 1965. The car in the foreground of this image clearly shows it to be in the 1960s. (Courtesy of Tripp Sloane.)

Oceanfront lots could be purchased for $500 in 1955 only if landowners were to start construction on the home within six months of purchase. (Courtesy of Tripp Sloane.)

Three

SUNSET BEACH

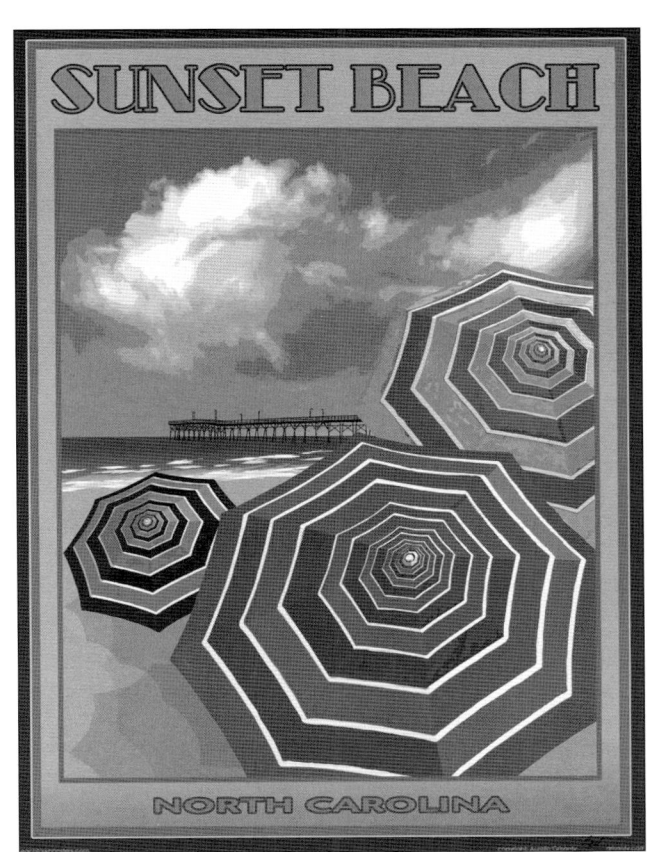

Mannon C. Gore purchased Bald Beach in 1955 from the Brooks family, who had owned it since the 1700s. The renamed Sunset Beach is the southernmost barrier island in North Carolina. (Courtesy of Aurelio Grisanty/ Beach Town Posters.)

Mannon C. Gore is shown here at 19 years old. Mannon worked at Ohio port cities as a young man and later became the visionary behind Sunset Beach. He purchased Bald Island from the Brooks family in 1955. He was a farmer and sold his farms in order to purchase the island. He thought that the sunsets on the island defined the property, and he renamed it Sunset Beach. One of his most innovative designs was the historic pontoon swing bridge. On October 11, 1982, Mayor Kanoy introduced a resolution recognizing Mannon C. Gore as the architectural father of the town of Sunset Beach and paid tribute to him as a farmer, citizen, and developer of the unique community. (Courtesy of Ed Gore.)

This is an aerial view of the back of the Sunset Strip Motel, the pier, and the first houses on the island. In 1963, the Town of Sunset Beach was chartered with 30 residents; the population grew to 72 by 1972. In 1963, an oceanfront lot cost $1,000. (Courtesy of Ed Gore.)

The original wooden bridge was engineered from World War II surplus barges. The metal and wood ramps would go up or down as the barge floated on low or high tide. A cable system attached to a pylon would swing it out of the way when boats needed to go through. (Courtesy of Ed Gore.)

Mannon Gore was a gifted mechanical engineer. He first built a small dredge that he called the *Little Dawn* in honor of his niece. Gore modeled it after the much-larger dredge that he served on while in the Coast Guard. He used *Little Dawn* to build two causeways—one on the island and the other on the mainland. Then, he engineered World War II surplus barges so that they swung like a door, opening and closing across the Intracoastal Waterway and connecting the two causeways. (Courtesy of Ed Gore.)

Mannon, with *Little Dawn*, is hard at work building the causeway, using dredge spoils. Mannon had trucks haul in clay to stabilize Sunset Boulevard. It took four years for the state to take the road because there had to be five houses per mile before a road could be state-owned. (Courtesy of Ed Gore.)

Mannon C. Gore was the first mayor of Sunset Beach, in 1963. Mayors that followed included Edward K. Proctor, W.E. Simons, Winifred Wood, Shelton Tucker, Frances Kanoy, James E. Gordon, M. Mason Barber Jr., Cherri Cheek, Ronald Klein, Richard Cerrato, and Ron Watts. (Courtesy of Ed Gore.)

This is a very early photograph of the first house Mannon built. The photograph may have been taken before the home was completed because the grounds are not manicured and Hurricane Hazel probably destroyed the pine trees in the photograph. The family lived there until 1972. (Courtesy of Ed Gore.)

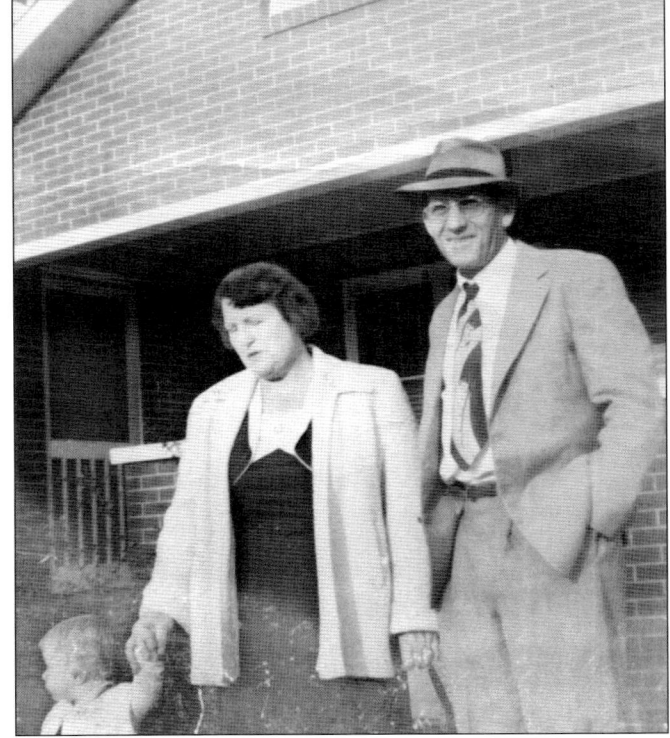

This is a Model 8 Northwest Crane dredge that was used from 1973–1975 in dredging operations. Dredging is usually carried out at least partly underwater for the purpose of gathering up sediment and transferring it to a different location. This Model 8 dredge encountered a storm and sank. (Courtesy of Ed Gore.)

Mina Orea and Mannon C. Gore stand with one of their grandchildren in front of Gore's residence on Gore Road. This is the home he retreated to in order to ride out Hurricane Hazel and the same home at which he offered up refuge to the residents at Ocean Isle Beach prior to the storm. (Courtesy of Ed Gore.)

Mannon is seen standing in front of Gore Ditch. This is the lighter side of Mannon that many did not have the opportunity to see. He had a great sense of humor and loved to joke around. He would always clown around with the bridge tenders. (Courtesy of Ed Gore.)

The Gore Ditch is the long section running west of the bridge. On January 14, 1981, it was opened temporarily to hundreds of clam-diggers; they waded through knee-deep mud. According to the Brunswick County Commercial Fishermen's Association, clams were selling for as much as 15¢ each. (Courtesy of Ed Gore.)

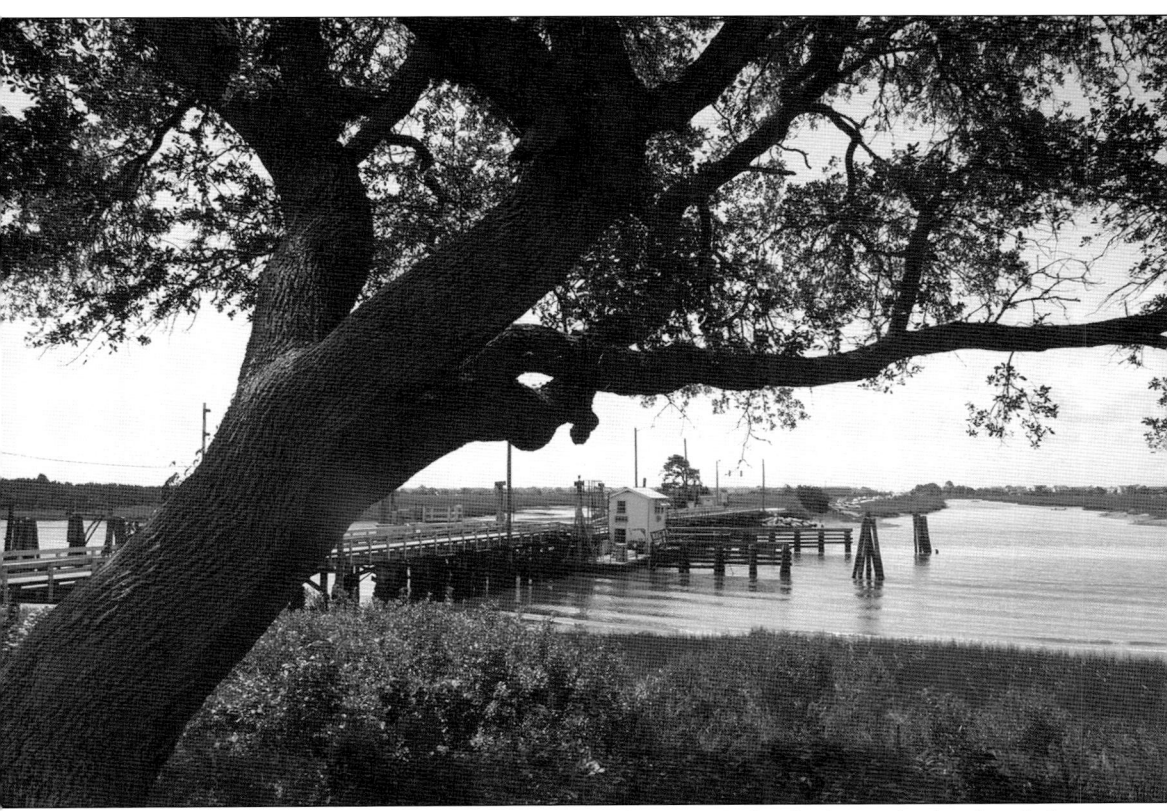

Mannon and his employees began building the bridge in 1957 by dredging the land and the marshes to install the causeway and put the pontoon bridge in place. In May 1958, the bridge and causeway were completed. The cost to build the pontoon bridge was less than $50,000. (Courtesy of Dianne Walker.)

Here, a bridge tender is seen below the bridge house to fire up the hydraulic system. Maneuvering the floating bridge barge sideways to allow boats to pass generally took 15 minutes out of each hour. Bridge tenders included Rick Branning, Bill Prince, Tom Hewett, Ed Danka, Al Theimer, and Roger McPherson. Hewett was a bridge tender for Holden Beach and Ocean Isle Beach prior to coming to Sunset Beach. (Courtesy of Ed Gore.)

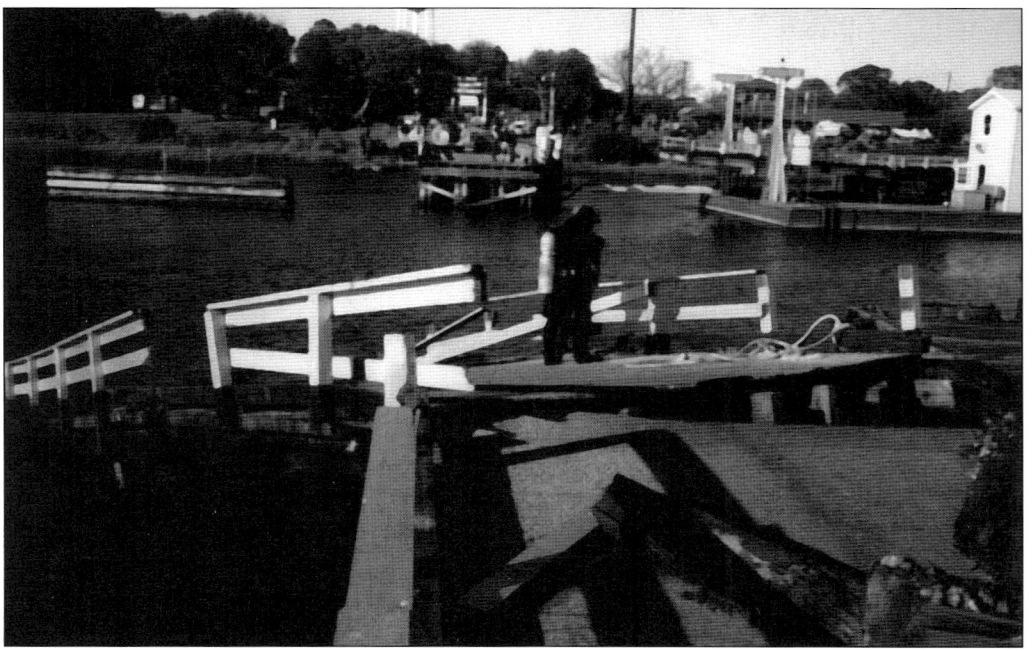

Shown here is a pontoon section after the bridge broke. Danny Hewett was the bridge tender on duty when the break occurred. The pontoon section broke away from the stationary part of the bridge and floated toward Wilmington. Eventually, the tide moved the pontoon to the edge of the waterway, and both Hewett and the pontoon were rescued. (Both, courtesy of Ed Gore.)

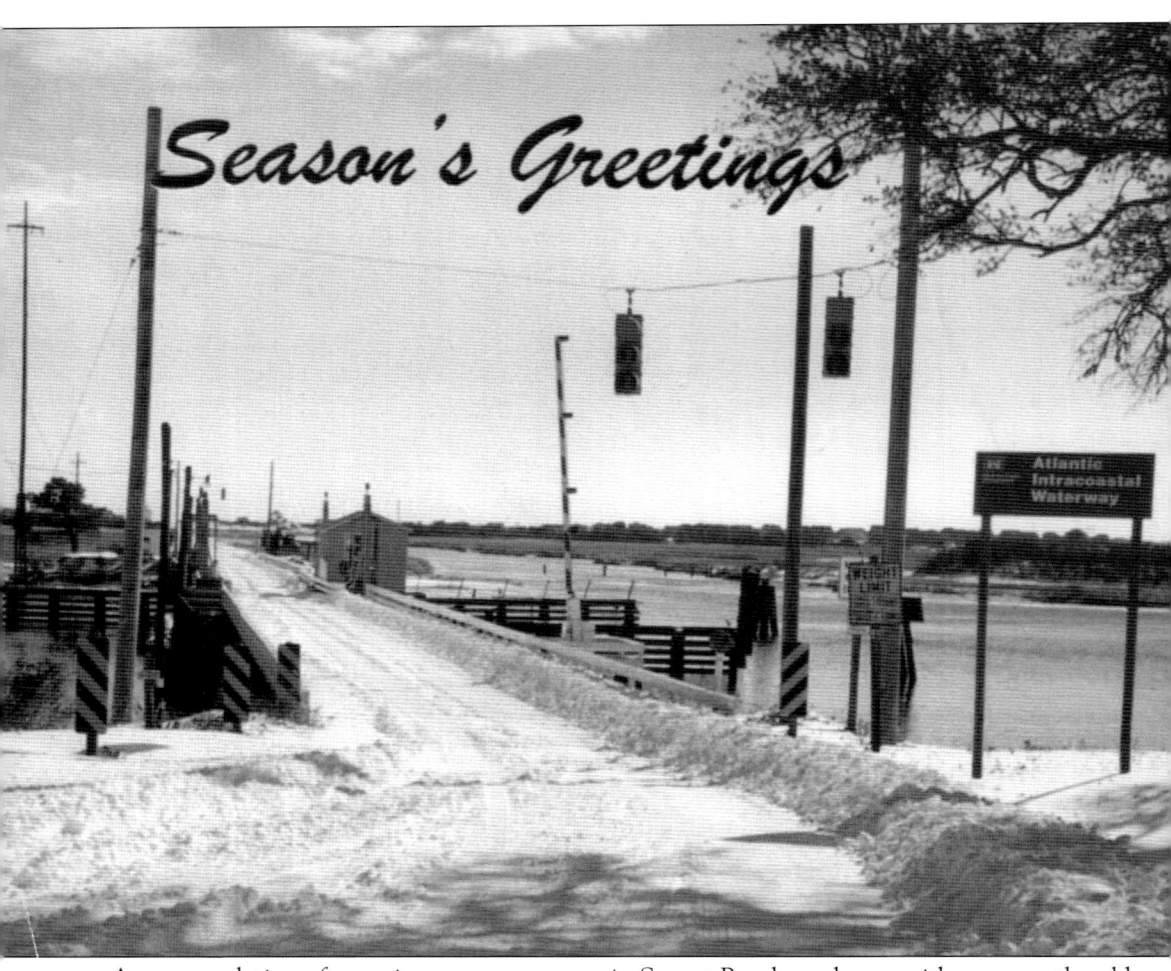

An accumulation of snow is a rare occurrence in Sunset Beach, and even with snow on the old bridge, it was never closed. (Courtesy of Ed Gore.)

Riding down the Intracoastal Waterway, one can often spot several goats at rest on Goat Island. For as long as anyone can remember, a herd of goats has called these uninhabited spoil islands near Ocean Isle Beach and Sunset Beach home. Their presence may date back to the 1930s, after the spoil islands were created from the dredging of the Intracoastal Waterway. (Courtesy of Kelly Frink.)

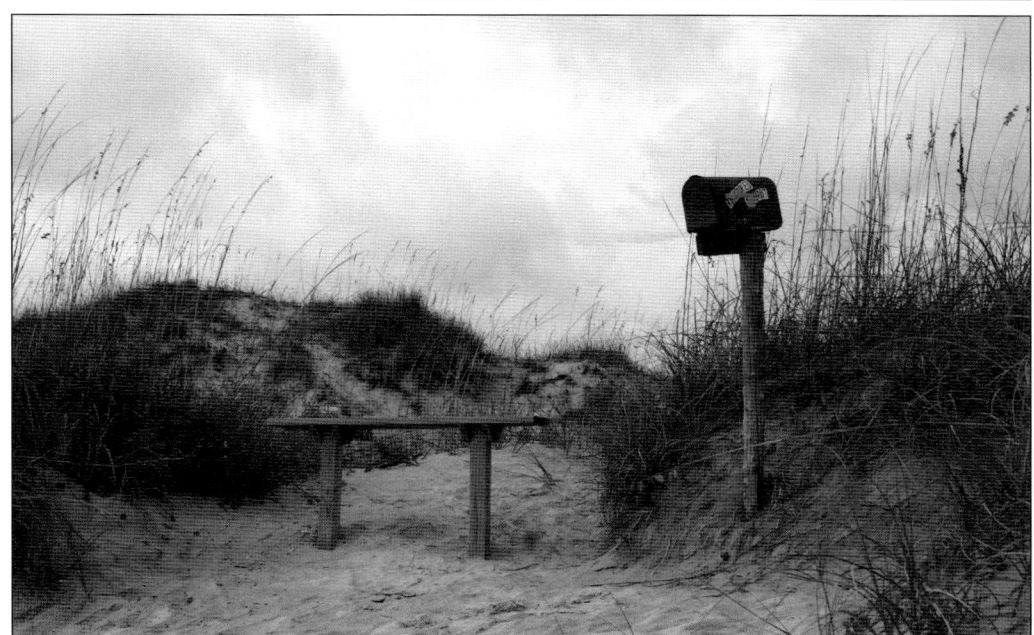

86-year-old Frank Nesmith, along with visiting vacationer Claudia Sailor, of Fayetteville, put up the "Kindred Spirits" mailbox, which included a notebook in the 1970s. Today, the mailbox is filled with dog-eared notebooks, pencils, and pens along with heartfelt stories, poems, memories, and the occasional sketch. (Author's collection.)

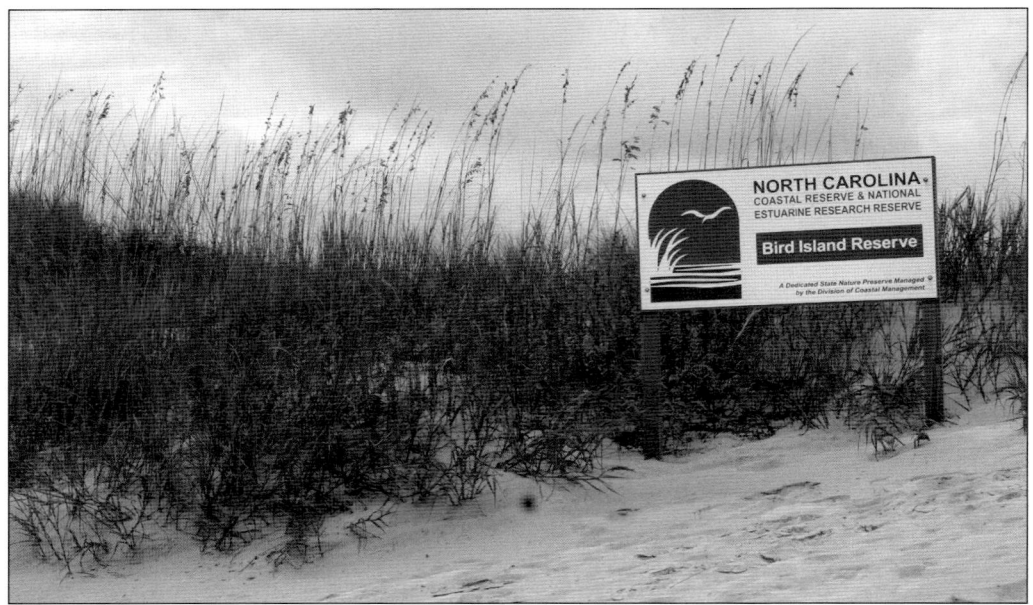

Bird Island Reserve is a rich ecosystem. Ralph and Janie Price owned the property on which the Bird Island Reserve is located and originally planned on building a family compound on the island. At one point, they had a bridge constructed, but it mysteriously caught fire and was completely destroyed. Unable to obtain the proper permits to build their family estate, they sold the property. (Author's collection.)

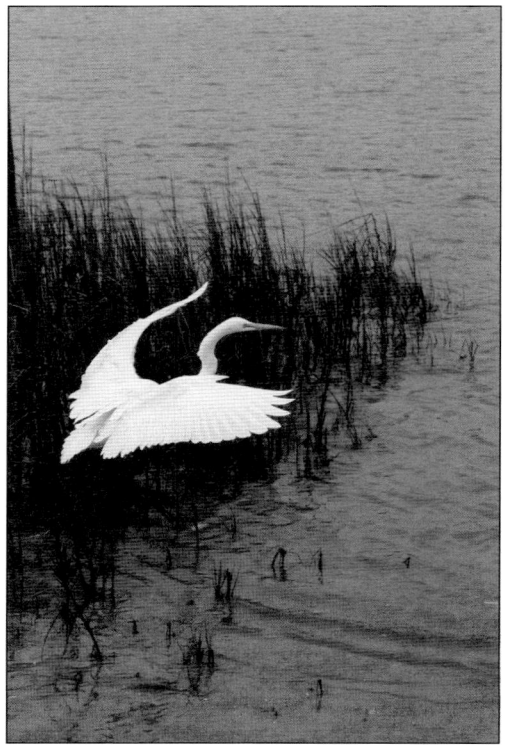

The State of North Carolina used $4.2 million of public and private funding to purchase the land and create a 1,300-acre coastal reserve, which includes 147 acres of upland and 1,150 acres of marsh and wetlands. The land was purchased from the Price family of Greensboro using the following funding sources: North Carolina Clean Water Management Trust Fund ($2.75 million), North Carolina Natural Heritage Trust Fund ($750,000), and North Carolina Department of Transportation ($720,320). (Author's collection.)

More than 6,000 visitors and property owners signed letters to save the bridge from demolition. Linking the island and the mainland, the bridge was a defining aspect of Sunset Beach. It has been the subject of thousands of photographs and many paintings. (Courtesy of Gordon Bokelman.)

The bridge is being taken apart here. With the help of many people, the land was prepared, and the old bridge was carefully moved in sections to its new home. (Courtesy of Gordon Bokelman.)

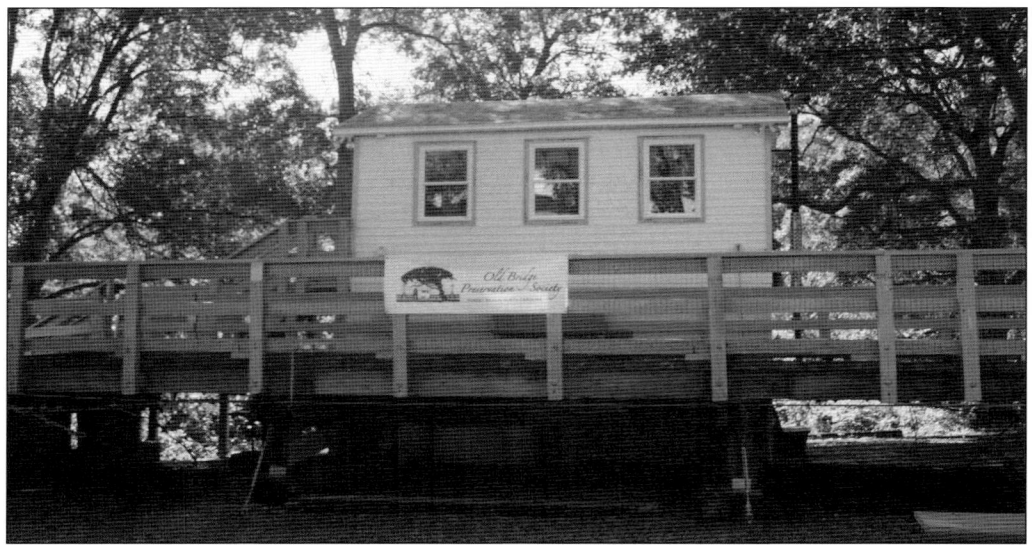

The tender house sits in sight of the new Mannon C. Gore Bridge. The old 110-foot span and the tender house were moved to the mainland on land donated by Ronnie and Clarice Holden. The Old Bridge Preservation Society turned them into a museum in order to save a piece of island history. The museum features historical displays of the bridge, blockade-runners, and other interactive exhibits. (Author's collection.)

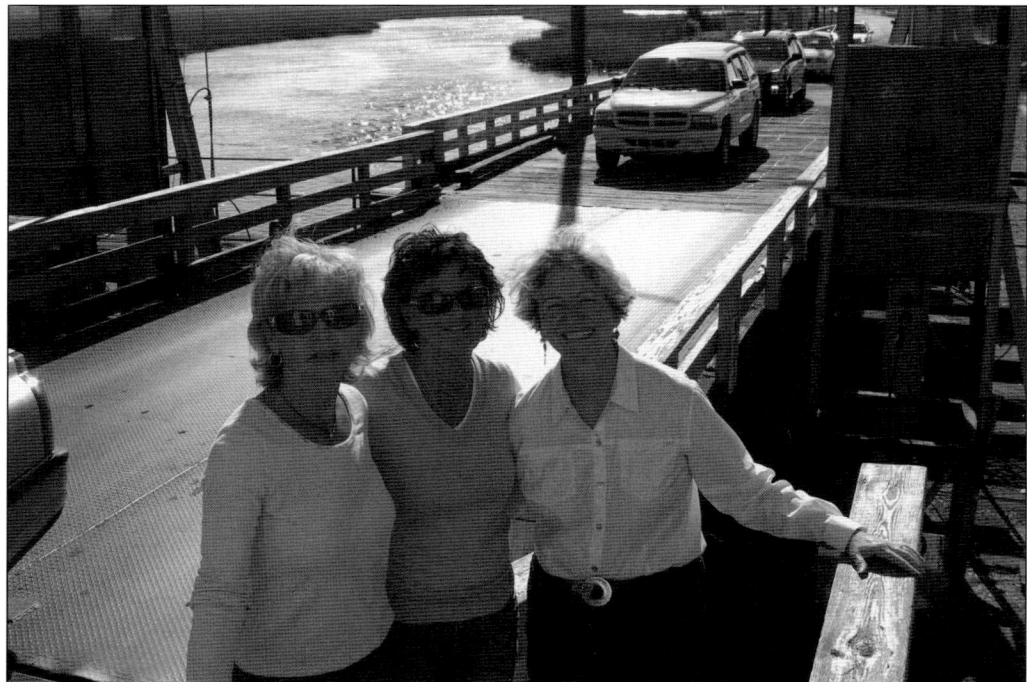

Three Sunset Beach women—from left to right, Karen Dombowski, Chris Wilson, and Ann Bokelman—wanted to preserve the iconic swing bridge and its history for future generations and collected over 6,000 letters to prevent its demolition. From this initial effort, the Old Bridge Preservation Society was formed in the summer of 2010. (Courtesy of the Old Preservation Society.)

This photograph of Louise Reynolds was taken in 1932 at the family's country home just outside of Winston-Salem. (Courtesy of Leigh Ingram.)

"Big" Stuart Ingram entered service as an Air Force pilot in 1951 and spent most of his time in England during the war. (Courtesy of Leigh Ingram.)

Shown here is the Ingram Planetarium. World War II airman Stuart Ingram learned to navigate his aircraft by looking at the stars, and after the war, he continued to look to the night sky, pointing out different constellations to his family and friends. Because of this fascination, Stuart and his wife, Louise, dreamed of a planetarium where others can share Stuart's knowledge of the stars. Ingram Planetarium opened in May 2002 in Sunset Beach. (Courtesy of Ingram Planetarium.)

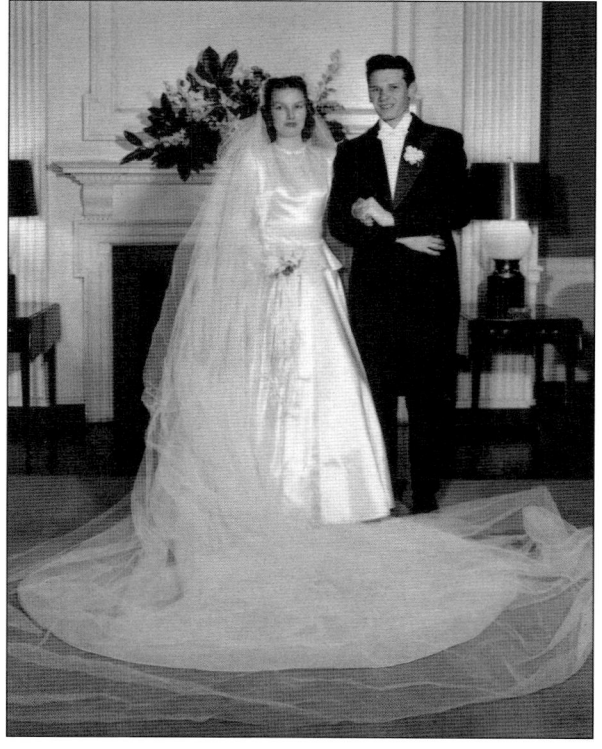

Here are Stuart and Louise Ingram. Even as a young couple, the Ingrams sought ways to contribute to their community. With the first donation from his mother-in-law; the encouragement of a steering committee; the generosity of numerous friends; and the support of his wife, the local business community, and the citizens of Brunswick County, Stuart Ingram's visions of the Museum of Coastal Carolina and Ingram Planetarium are a reality today. (Courtesy of Leigh Ingram.)

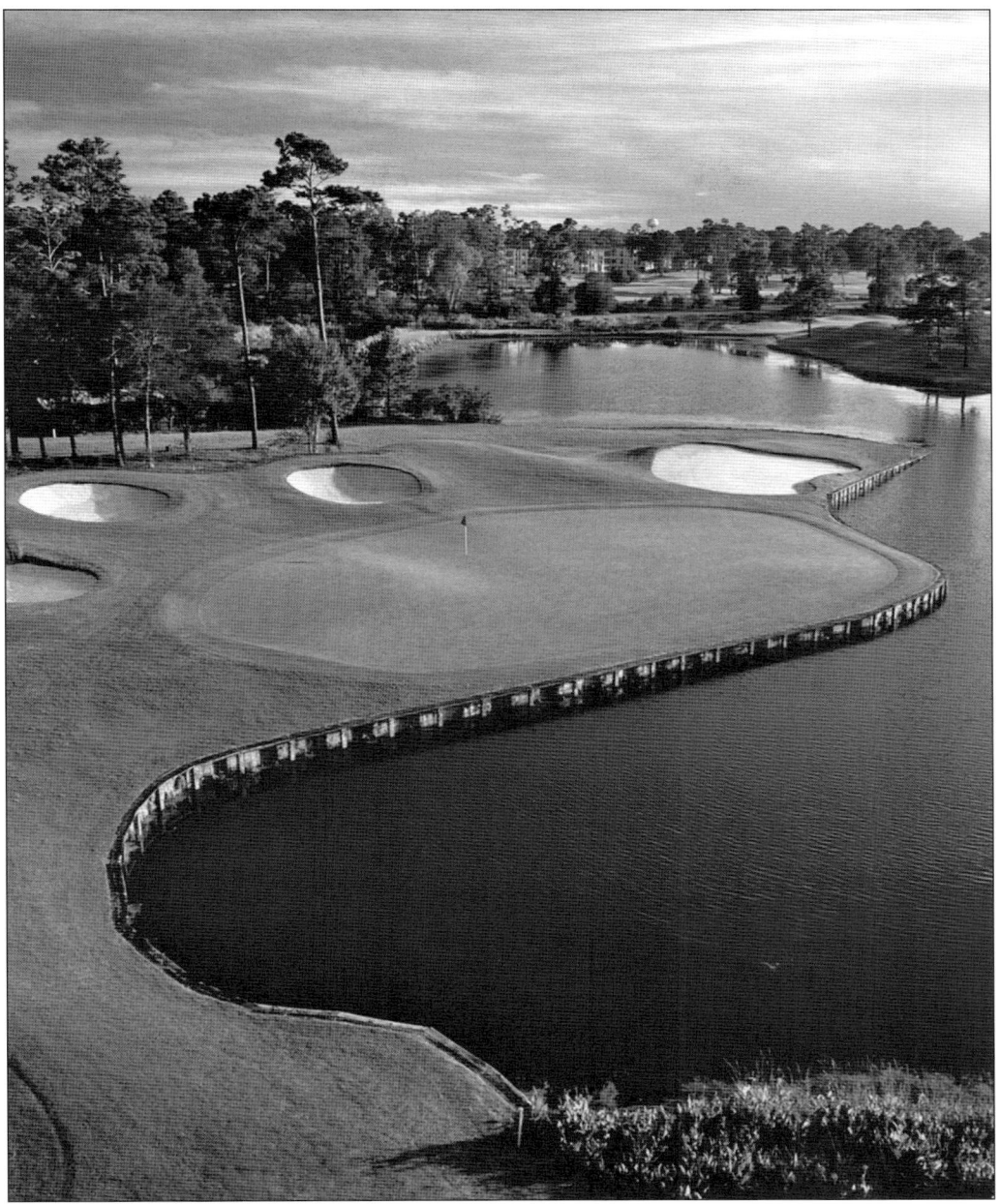

The Sea Trail Golf Resort & Convention Center covers over 2,000 acres in Sunset Beach, with 54 holes of championship golf by designed by Rees Jones, Willard Byrd, and Dan Maples. Ed Gore, Paul Dennis, Miller Pope, and Harris Thompson developed Sea Trail after a purchasing the land from International Paper Company. (Author's collection.)

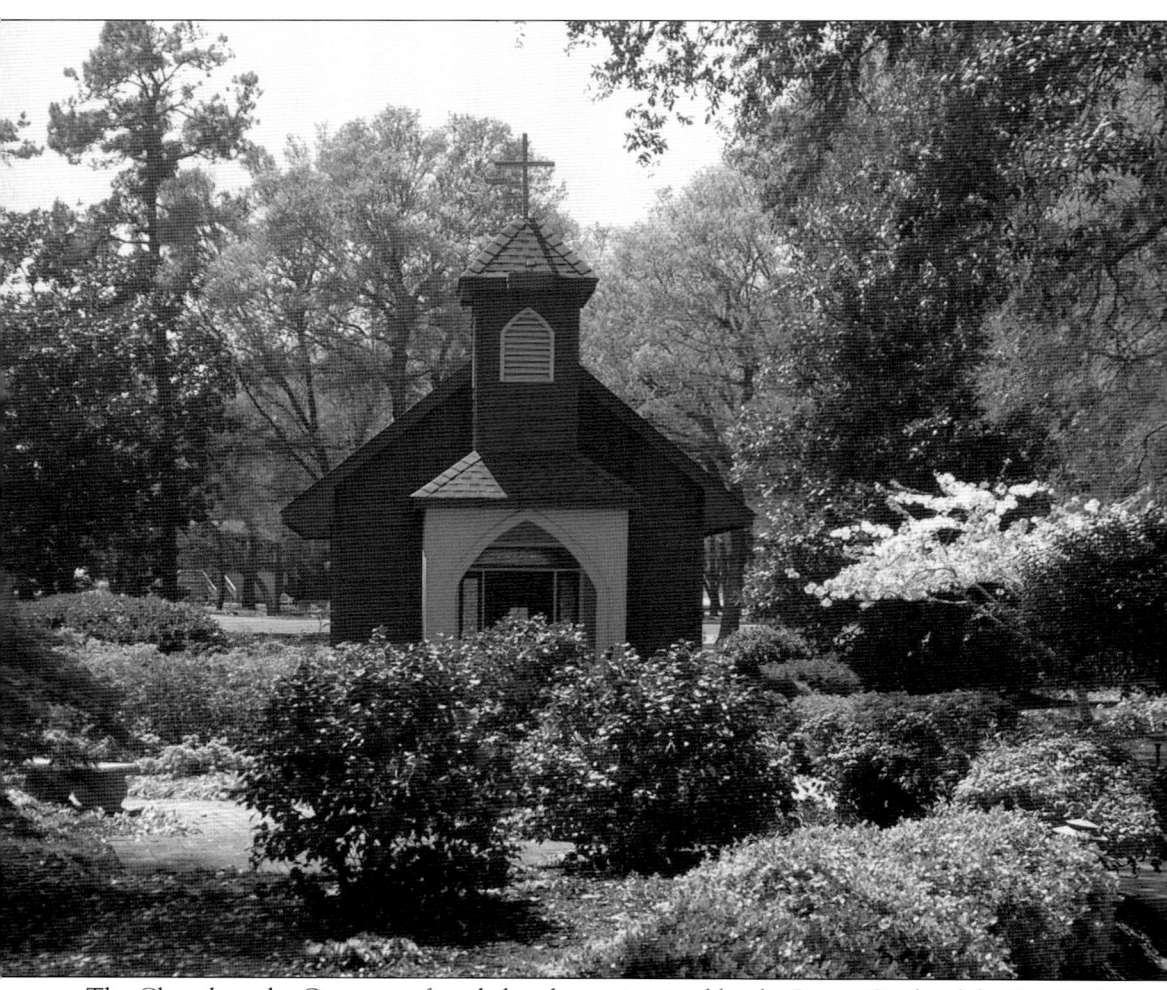

The Chapel on the Green was founded and is maintained by the Prayer Circle of the Sea Trail community. It is open daily as a place to pray, meditate, or simply find a sense of peace in times of stress. Also, it is available to Sea Trail residents for small weddings and memorials. The Chapel on the Green has a Memorial Garden with names of deceased Sea Trail residents etched in bricks forming a walkway through the lovely garden. The Prayer Circle was founded by Ro Walker and Jane Bye. (Courtesy of Joan Mason.)

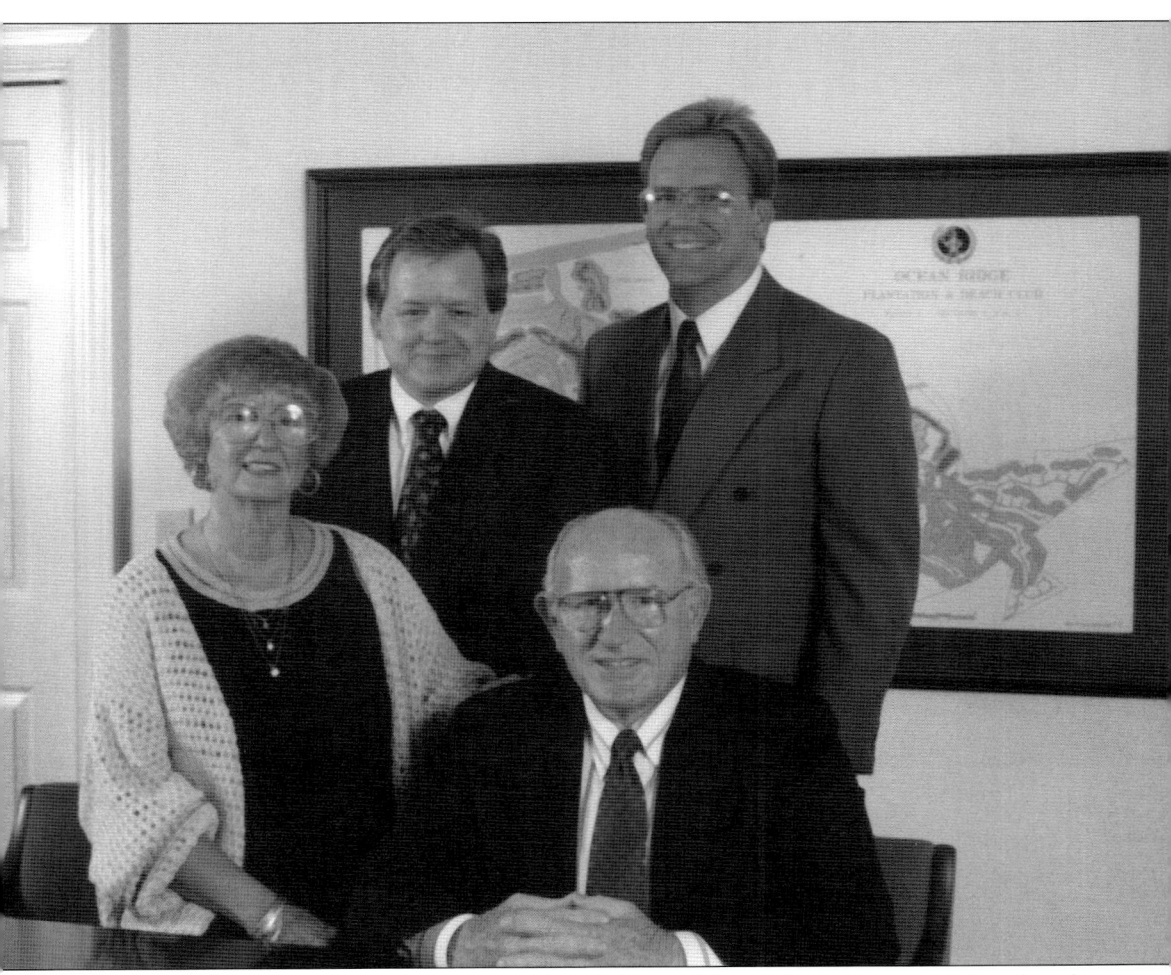

Ed and Dinah Gore are seen with their sons Greg (left) and Edward. Both Greg and Edward work to carry on the Gore legacy as they contribute to the community and promote Sunset Beach. (Courtesy of Ed Gore.)

Each year, volunteers monitor turtle nests and help wayward turtles find their way back to the sea. Nesting season on Brunswick County beaches runs from early May through August. Between the months of July and August, volunteers are busy with hatchling boils. A boil is when more than 100 hatchlings emerge from the nest. The volunteers also conduct educational programs at Ingram Planetarium. (Courtesy of the Sunset Beach Turtle Watch Program.)

The Sunset Beach Turtle Watch Program (SSBTWP) is a private, nonprofit program that works with volunteers to help monitor and record turtle nesting sites and hatches. Volunteers and visitors dig a path to the ocean in order to help the hatchlings on their journey to the ocean. (Courtesy of Gloria Hillenburg.)

This sea turtle sculpture at the entrance to the beach was dedicated to Carmel Zetts on September 8, 2006, for her efforts in the education and care of sea turtles. Minnie Hunt started the turtle watch program in the early 1980s. She turned the helm over to Zetts, who encourages conservation and continues to educate the general public through programs at Sunset Beach, Ingram Planetarium, civic and public organizations, and schools. (Author's collection.)

Dr. Gene Conti, secretary of the North Carolina Department of Transportation, presents a replica sign for the new bridge to Mannon C. Gore's son Ed Gore Sr. and his wife, Dinah, at the bridge dedication. (Courtesy of Ed Gore.)

The Mannon C. Gore Bridge is a graceful structure that provides views of the marshland. The new bridge was designed and built at a cost of $32 million. For nearly three decades, Sunset Beach residents debated whether or not to replace the old bridge with a new, taller span. Proponents were worried about the safety of the old bridge and the long waits. Opponents feared that a new bridge would jeopardize the tranquility of the island. (Author's collection.)

Ed Gore Sr. is with his wife, Dinah, at the bridge dedication. Ed is wearing Mannon's beloved hat. Mannon wore his cap wherever he went, and he was known in the area for it. Mannon's sailing cap was included in the Sunset Beach Time Capsule highlighting the first 50 years of the island. (Courtesy of Ed Gore.)

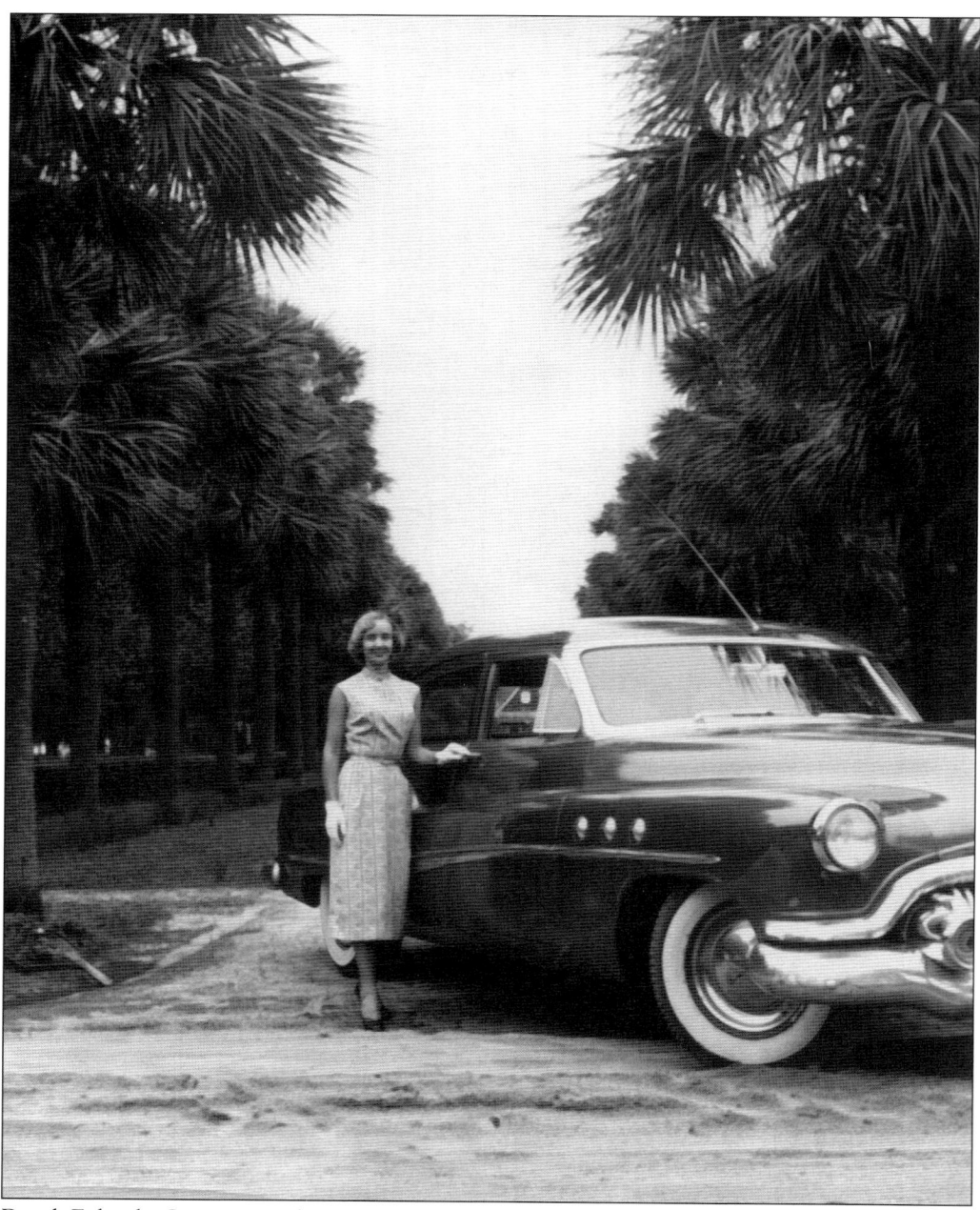

Dinah Eubanks Gore was working as a banker in Kinston, North Carolina, when she encountered the man who would change the course of her life. She met Ed Gore on a weekend outing at the coast, and a week or so later they were dating. After marrying Ed in 1959, Dinah became a key player in the family business. They purchased the company from Mannon Gore and, using his vision, developed Sunset Beach. In addition to Sunset Beach, they went on to develop Ocean Ridge Plantation and Sea Trail Golf Resort. (Courtesy of Ed Gore.)

In 1964, Mannon C. Gore constructed the first real estate office beside his home; it housed Sunset Beach Realty. This family tradition lives on today through Gore's grandson Gregory S. Gore in the form of Century 21 Sunset Realty and Sunset Vacations. (Courtesy of Ed Gore.)

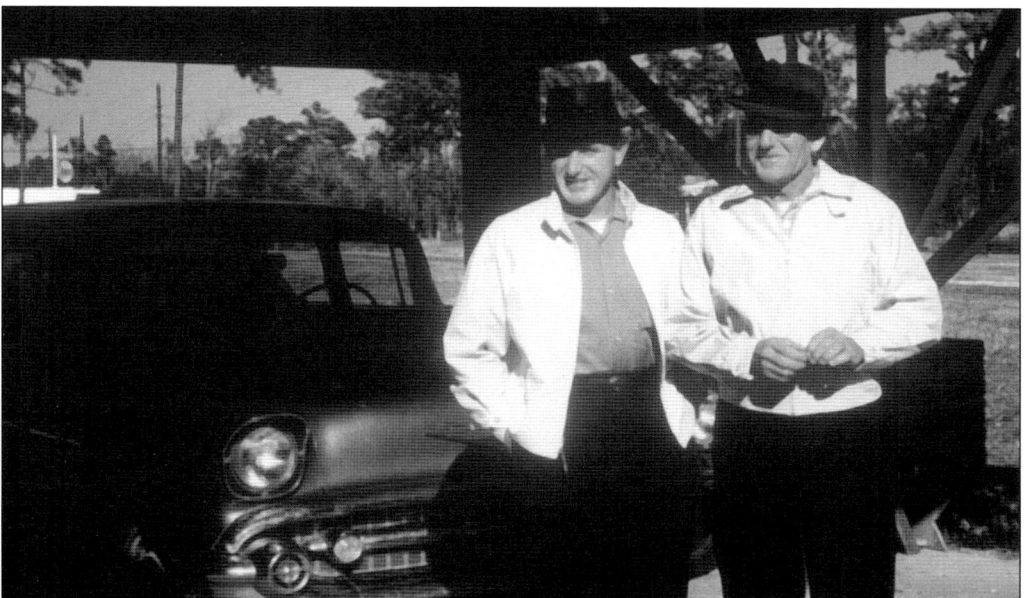

Mannon C. Gore is pictured here with his son Ed Gore. Edward M. Gore Sr. succeeded his father as head of the Sunset Beach and Twin Lakes development company. After graduating from Campbell in 1952, Ed went on to earn a degree in business from East Carolina University. He joined the family business in the late 1950s. Together, they successfully developed and shaped the Sunset Beach into what it is today. (Courtesy of Ed Gore.)

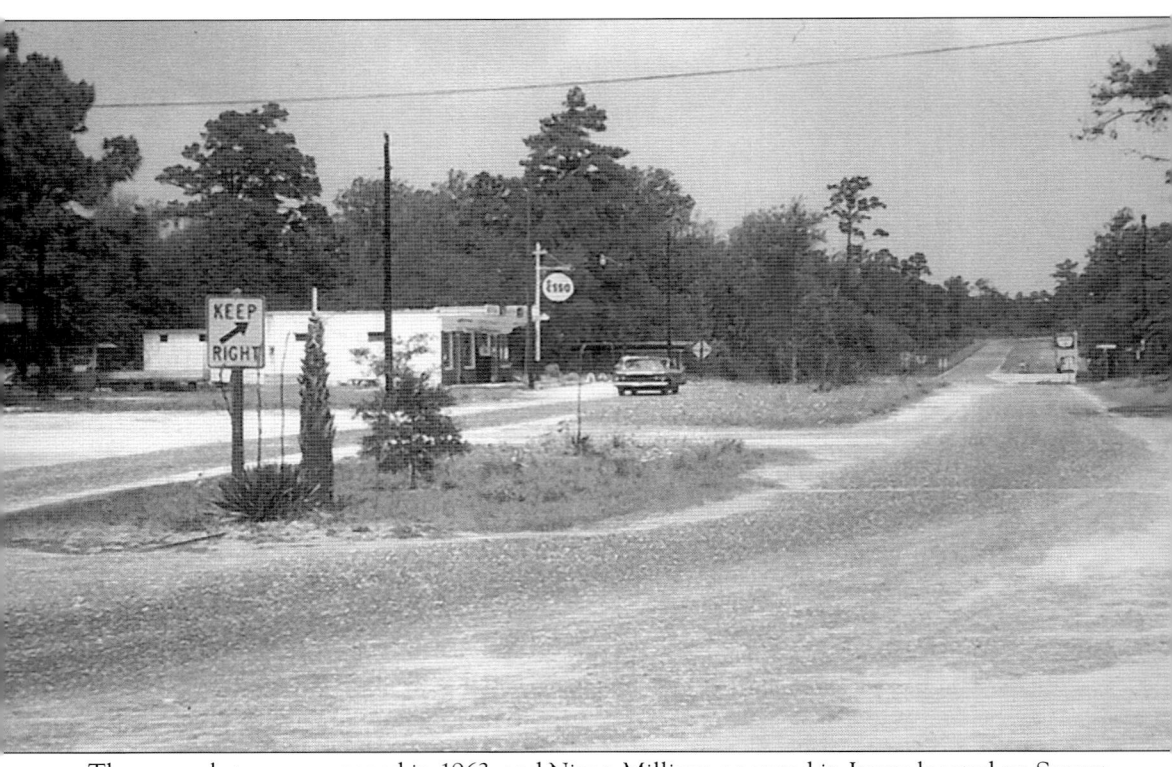

The general store was opened in 1963, and Nivan Milligan operated it. It was located on Sunset Boulevard. It was a one-stop shop for tackle, rods, reels, hardware, and groceries. (Courtesy of Ed Gore.)

In this image, a fisherman is catching a big one off of the Vesta Pier. "Duke" Emerson Foyle holds the flounder while Ed Gore, his brother-in-law, inspects the rest of the catch. The *Vesta* was a Civil War blockade-runner that ran aground at Bald Beach in 1864. The *Vesta's* hull was an attraction on the island for years until it finally was buried in the early 1970s by the accreting sand. (Courtesy of Ed Gore.)

From a humble farming background to generous philanthropist, Dinah Gore generously serves her community. The 55,000-square-foot Dinah E. Gore Fitness and Aquatics Center at Brunswick Community College is available not only to students but also anyone in the community. She has also contributed significantly to the Brunswick Community College Foundation. Dinah strives to be a role model to students at BCC and works to ensure their success. (Courtesy of Ed Gore.)

The much-anticipated pier opening occurred on June 6, 1960. A few years later, in 1964, the Kanoys bought the Vesta Pier and operated it for a few years. The Pier Real Estate and Store was sold to Ed and Dinah Gore. They dismantled the old pier building and constructed a new pier house with two stories. At low tide before the pier was built, fishermen would swim out to where the *Vesta* was located and stand atop of the vessel's boilers to fish. (Courtesy of Ed Gore.)

Hurricane Hugo destroyed the bottom portion of the pier in 1989. The Gores renamed the pier Sunset Beach Pier, and Mark Kaplan currently operates it. Several years ago, the pier staff installed a very informative self-guided walking tour. It has photographs and information about the islands' founders, historic hurricanes, bridges, and much more. (Author's collection.)

Walking onto the pier at Sunset Beach, people will see a hand-painted yellow-and-red compass rose. When a person walks to the end of the pier, he or she is facing south; the beach runs east to west, allowing for the beautiful sunsets that gave Sunset Beach its name. Without the compass, many visitors might think they were facing east while gazing out at the ocean. (Author's collection.)

Here is the Gore family in 1962. Family members surround Mina and Mannon Gore at center. The little girl in the front left is Dawn, Mannon Gore's niece, and the namesake of his dredge. (Courtesy of Ed Gore.)

Shown here are Barbara (left) and Vivian Gore with their mother, Mina. Barbara and Vivian used to climb the big oak tree next to the bridge and watch the yachts, barges, and fishing boats pass by. That oak tree has become synonymous with the bridge over the years, as thousands of photographs have been taken with the tree framing the bridge. The girls would also swim out to the bridge and dive from the barge into the water. (Courtesy of Ed Gore.)

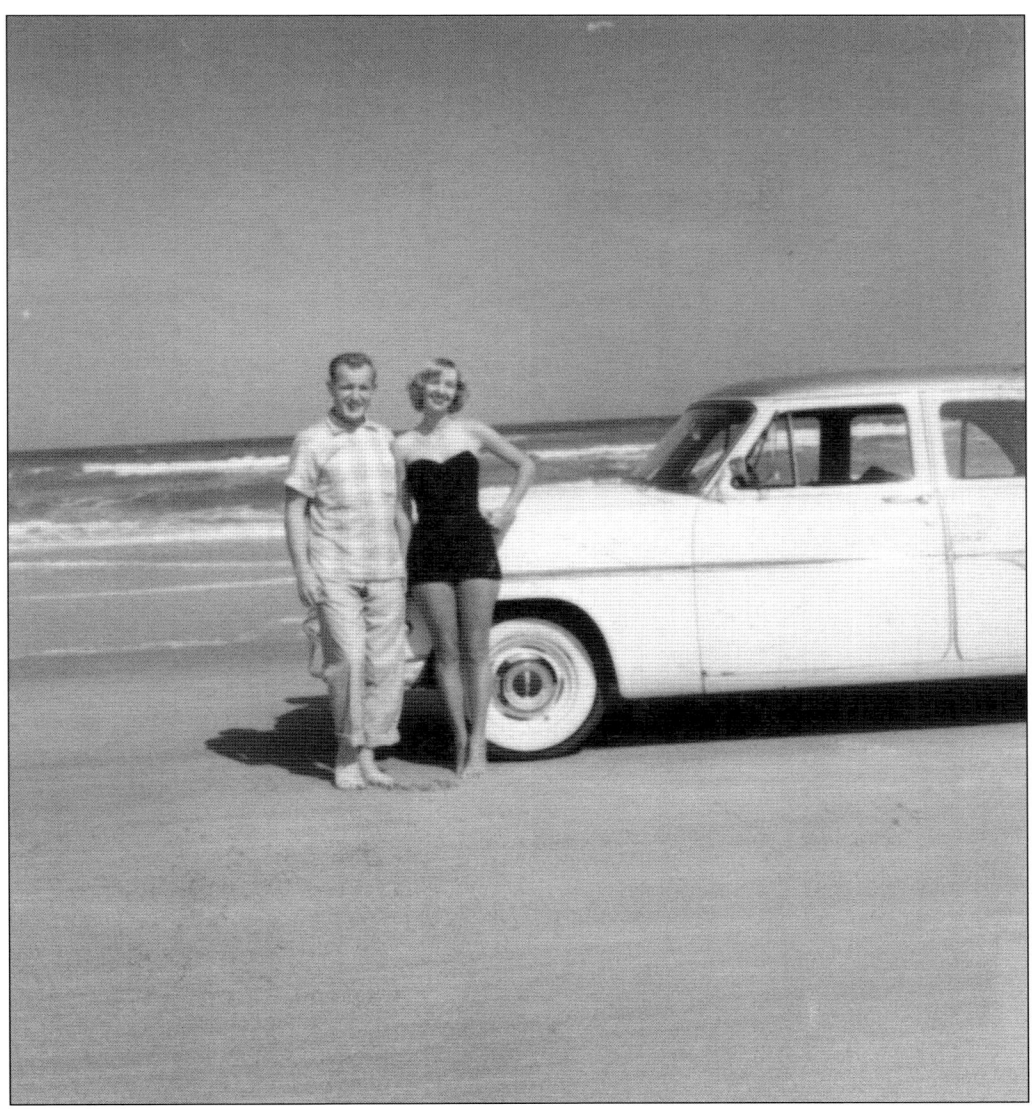

This image shows Ed and Dinah Gore in 1959. In the early years, driving was allowed on Sunset Beach. Eventually, driving on the beach was discontinued in order to protect beach visitors and to protect the delicate ecosystem. A resolution was adopted in August 1971 restricting any motor vehicles on the beach, including dune buggies, automobiles, trucks, and motorcycles. (Courtesy of Ed Gore.)

Here are, from left to right, Gregory Stewart Gore, Gilbert Craig Gore, and Edward Mannon Gore Jr. The 15,360-square-foot Gilbert Craig Gore Arena at Campbell University is named in memory of Gilbert Craig. (Courtesy of Ed Gore.)

Edward Gore Sr. was part of an Air Force unit that monitored phone calls, telegrams, and even personal cards that Russians sent to their families. He was prohibited from traveling abroad for 10 years after his time in the service because the government felt he would be a target of the Soviets because of knowledge he gained while in the service. (Courtesy of Ed Gore.)

Tubbs Inlet separates Sunset Beach from Ocean Isle Beach. In 1966, Tubbs Inlet was filled in order to move it back to the original location it occupied in the late 1930s. From 1965 to 1970, Jim and Jackie Bowen operated a campground, Sunset Beach Campground, with a clubhouse near Tubbs Inlet. There were 150 campsites. The campground was closed in 1970. (Courtesy of Ed Gore.)

As a young boy, Ronnie Holden loved the ocean, and he loved fishing. He was also no stranger to hard work, having grown up in a family with a strict work ethic; he was always willing to pitch in. Ronnie attributes much of his success to family. (Courtesy of Ronnie Holden.)

Mannon C. Gore built Twin Lakes in 1959. He sold it in 1965 to Warren McCall and Joe Covert. After they purchased it, they could not find a tenant who could make it successful. Ronnie and Clarice Holden agreed to pay $50 month to rent the restaurant and officially opened January 1, 1970. After only three months, the young couple purchased the restaurant for $26,000. The payments were $227 per month. (Courtesy of Ronnie Holden.)

Here are Ronnie and Clarice Holden at their prom in 1969. The couple was married on July 25, 1969, and the next day reopened Coleman's Original Seafood Restaurant on the river in Calabash. Lucy Coleman had experienced health problems and was forced to close during the height of the season. (Courtesy of Ronnie Holden.)

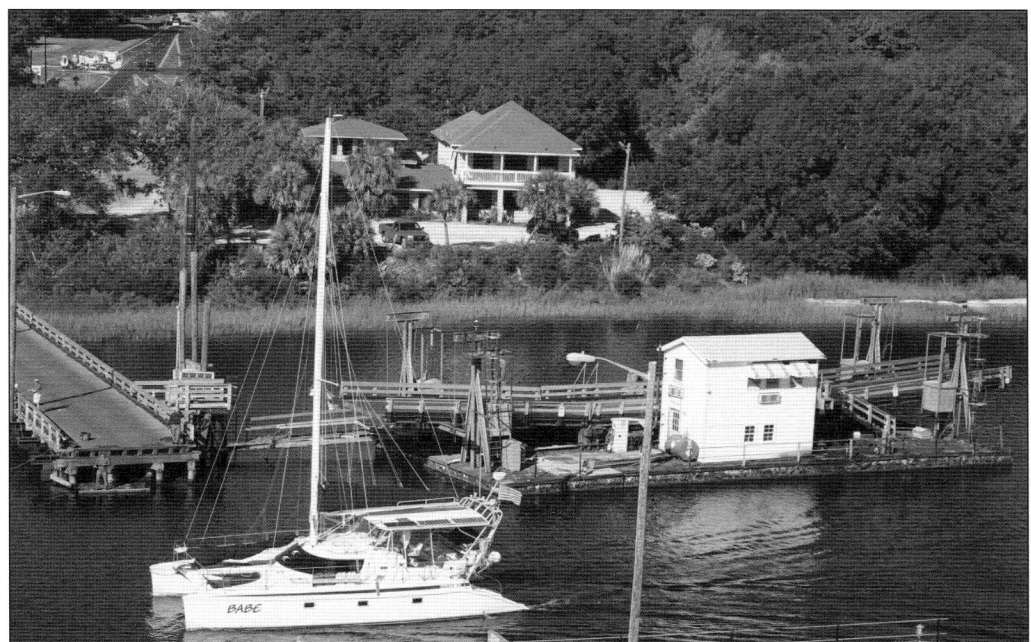

Twin Lakes Restaurant overlooks the Carolinas' last pontoon bridge. Many patrons at Twins Lakes come not only for the great food but also for the beautiful view of the Intracoastal Waterway. (Courtesy of Ronnie Holden)

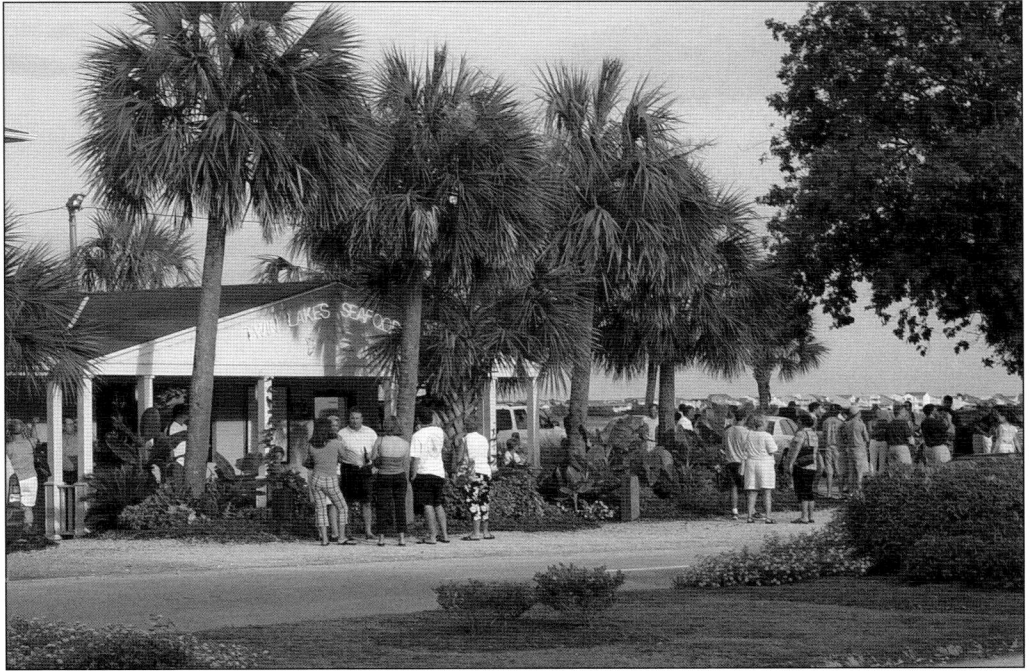

Twin Lakes Restaurant originally seated 75 people; today, it seats around 200, with an upstairs dining room added in 1997. According to Ronnie, this success came with a lot of hard work. (Courtesy of Ronnie Holden.)

Ronnie Holden is shown here in the Shallotte High School class of 1969 photograph. After high school, Ronnie started on his dream of owning a successful seafood restaurant. (Courtesy of Ronnie Holden.)

Four

FESTIVALS

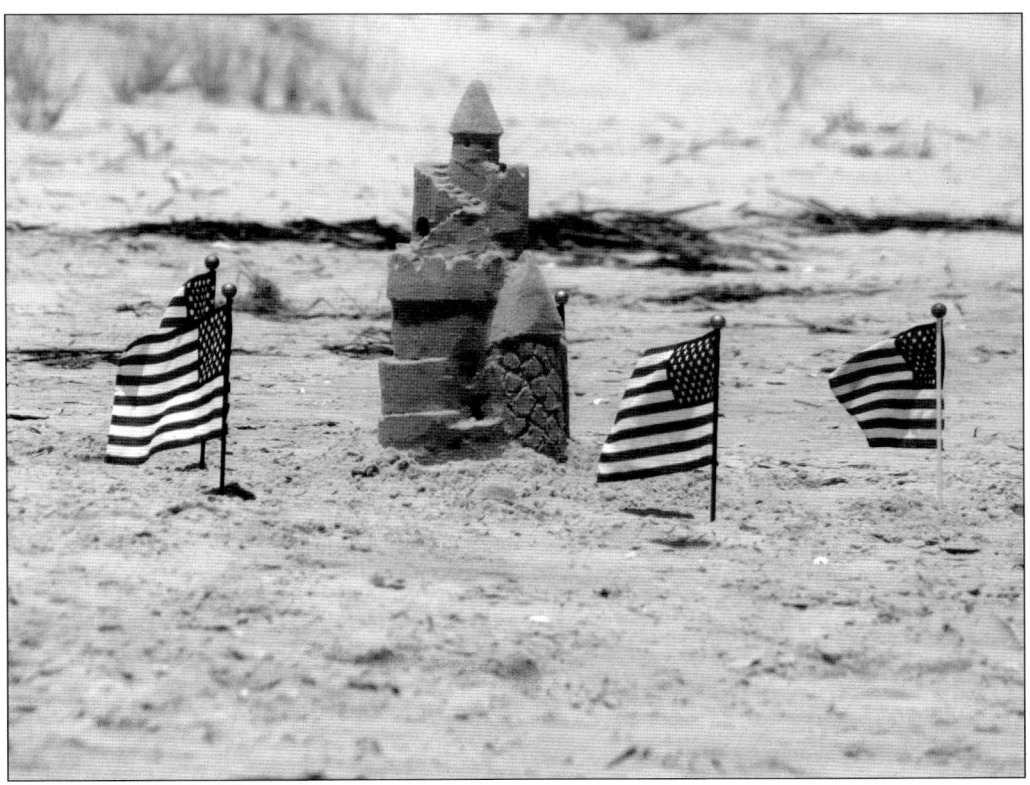

North Carolina Festival by the Sea is a two-day event that kicks off with a parade down the Holden Beach causeway. This is the only day of the year that one can walk across the Holden Beach Bridge, and each year, several hundred people take that stroll. Arts and crafts vendors are on hand with unique items available for purchase. Food vendors offer a variety of choices, including fresh seafood. The festival also includes live music, children's activities, a horseshoe tournament, and a sand castle building contest. (Author's collection.)

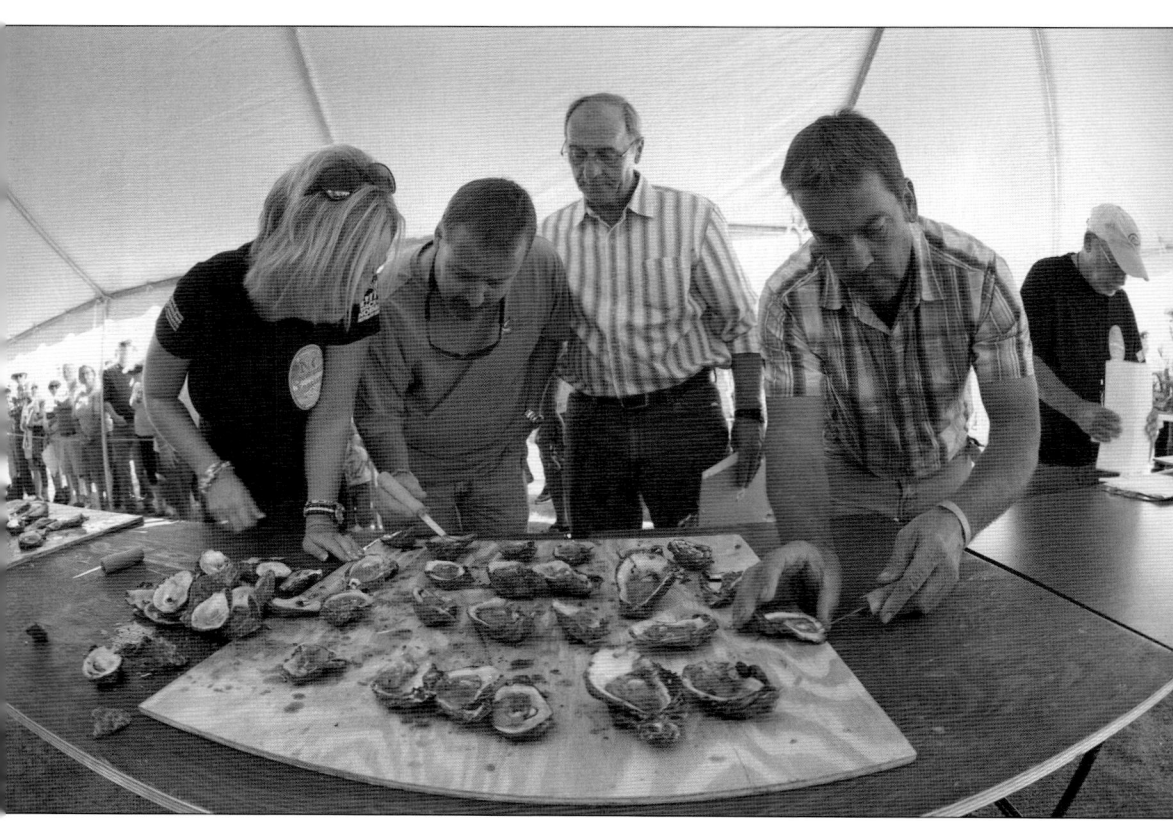

Here, judges are grading the shucked oysters for the shucking contest. Ocean Isle is well known for the Brunswick County Chamber of Commerce Oyster Festival that is held every October. This festival celebrates with steamed oysters, shrimp, and a wide variety of food from different vendors. There are many artisans and organizations exhibiting. Over 100 vendors bring their items to sell to the public while different live bands play. The North Carolina Oyster Festival in Ocean Isle Beach is the most exciting event of the year, according to the North Carolina Association of Festivals and Events. The Oyster Festival brings tons of visitors to Ocean Isle Beach, where they can enjoy constant live entertainment, a road race, a surfing contest, over 120 arts and craft stations, 13 local food vendors, an oyster shucking competition, and an oyster stew cook-off. Whether or not a person likes to eat oysters, the festival is a cannot-miss event for people of all ages. The famous oyster festival is held on Ocean Isle Beach during the third weekend of October. (Courtesy of Time2Remember.)

The Sunset at Sunset Festival features artists, writers, local charities, wineries, community organizations, and restaurants. Along with an annual run and a photography contest, bands play beach music throughout the day. (Courtesy of Guy F. Maple.)

The pontoon bridge model is an actual operating model of the decommissioned span. Pictured is an unidentified Old Bridge Preservation Society member showing a child the operating model of the iconic pontoon bridge. (Courtesy of Guy F. Maple.)

Discover Thousands of Local History Books Featuring Millions of Vintage Images

Arcadia Publishing, the leading local history publisher in the United States, is committed to making history accessible and meaningful through publishing books that celebrate and preserve the heritage of America's people and places.

Find more books like this at
www.arcadiapublishing.com

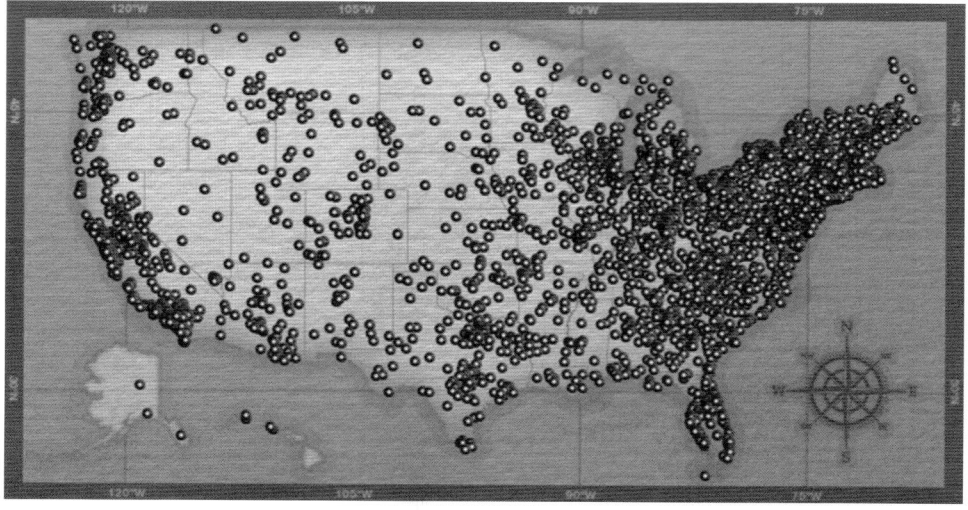

Search for your hometown history, your old stomping grounds, and even your favorite sports team.

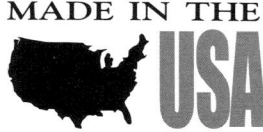